BROADSTAIRS
THROUGH TIME
Robert Turcan

AMBERLEY

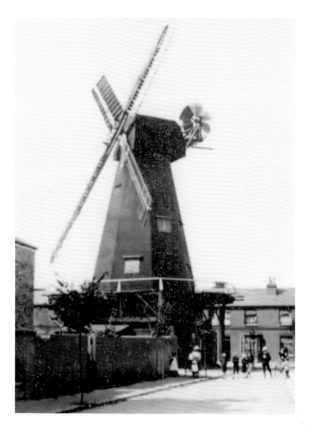

In every outthrust headland, in every curving beach, in every grain of sand, there is the storey of the earth.

Rachel Carsen

To the late Lillian Craigie, an inspirational teacher and past head of Rodmersham Primary School.

First published 2015

Amberley Publishing
The Hill, Stroud, Gloucestershire, GL5 4EP
www.amberley-books.com

Copyright © Robert Turcan, 2015

The right of Robert Turcan to be identified as the
Author of this work has been asserted in accordance with
the Copyrights, Designs and Patents Act 1988.

ISBN 978 1 4456 5001 2 (print)
ISBN 978 1 4456 5002 9 (ebook)

British Library Cataloguing in Publication Data.
A catalogue record for this book is available from the
British Library.

Typesetting by Amberley Publishing.
Printed in Great Britain.

Introduction

Stella maris, or star of the sea, is Broadstairs' motto. In every way the town fulfils this galactic rating. It has become the quintessential perfect Kentish seaside resort.

Historically its inland neighbour, St Peter's, is an older settlement with its Norman church and older established farming community. Now these settlements are interlinked, but until the eighteenth century Broadstairs, or Brad Stair, was a small fishing village with a modest shipbuilding reputation. During Napoleonic times however, cannon fortifications were constructed to meet the potential threat of French invaders. Around this time sea bathing became increasingly popular and hoys and then steam boats brought tourists from London. Building developments from Margate and Ramsgate were copied at Broadstairs. When the future Queen Victoria came to holiday at Pierremont house the town started to grow rapidly. Its popularity by the mid-nineteenth century can be gauged by Charles Dickens' affection for staying here. Much of the work on his most successful novel (*David Copperfield*) was completed here in his 'airy perch' at Bleak House overlooking the channel. The fictional character from this book of Betsey Trottswood is based on a close friend who lived in the house which now houses Charles Dickens Museum.

There are many ways that the present communities of St Peters and Broadstairs honour Dickens' memory. At the former an award-winning walk is performed by costumed actors who lead guests around their village entertaining them with local history and humour of a professional standard. In Broadstairs there is the Dickens Festival, which has been a social highlight for many years. Other music and food festivals enliven the calendar.

The main attraction of Broadstairs is its clean soft sandy beaches and safe shallow bathing waters. These were available to the masses once the railway line from London was connected in the 1860s. Urban expansion then became more dramatic as hotels and boarding houses sprang up to meet growing demand. A large proportion of these old buildings survive, albeit adapted to modern needs. In the main Broadstairs is fortunate that its leaders have valued its heritage as there are few examples of hideously contemporary developments which mar its overall attractiveness.

Exceptionally, its retail scene is lively. There are many lovely quirky independently run shops and cafes. Public houses often provide live music and there is a regular jazz festival. All recreational tastes and sports opportunities are catered for with rugby at Thanet

Wanderers Club, golf at North Foreland, sailing from the harbour club and bowls. The tiny cinema is exceptional as it shows films every day except for Christmas Day.

The healthy sea air has attracted a number of convalescent homes over the years. Preparatory schools have also been located here for similar reasons. The esteemed Wellesley House School in Ramsgate Road is one of particular note.

For leisure visits, days or long-weekend breaks have become increasingly more likely than longer weekly or fortnightly stays. Inexpensive foreign flights have changed consumer patterns. There is however, in the author's mind, no substitute for a day spent in the sunshine on Viking Bay with the occasional sortie to Morellis to savour their delicious ice-cream.

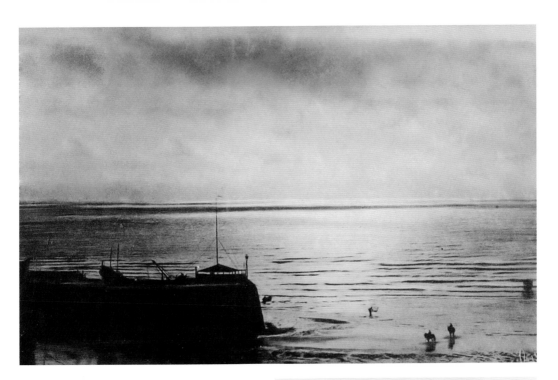

Beloved Broadstairs, Favourite Seaside Destination for Generations

Above, dawn breaks over a tranquil sea lapping the harbour and sands of the beautiful yet little-changing Broadstairs. Generations of children, like the ones below, have revelled in the freedom and safety of its sands to play, paddle and enjoy its entertainments.

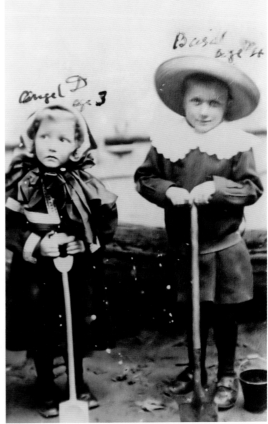

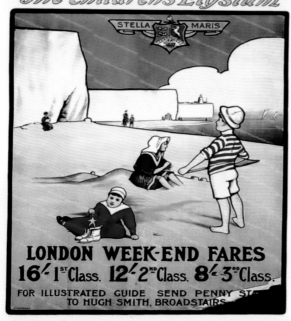

Broadstairs' Railway Link I
Broadstairs was first linked to
the railway system in 1863 and
due to posters, such as the one
adjacent, advertising it as a
children's Elysium, its popularity
with London visitors saw it grow
rapidly. Previously, coaches had
served to convey passengers from
nearby railway stations.

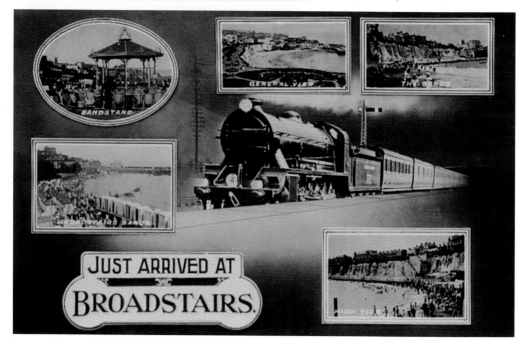

Broadstairs' Railway Link II
Electrification of the railway line to
Broadstairs occurred in 1970. By then
Southern Railways were managing
this network and their tourist posters
reflected a more modern image of
the archetypical family, featuring
them building sandcastles while dad,
puffing his pipe, benignly looks on.

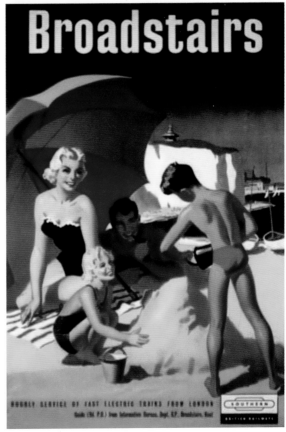

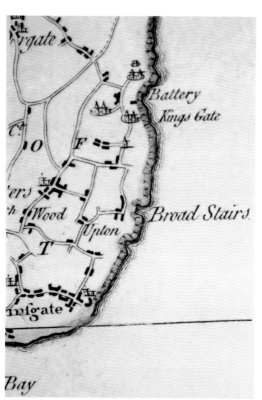

Broadstairs Development

Kitchen's map of 1794 shows Broadstairs as a small fishing village with a tiny population. By 1947 the earlier and previously greater settlement of St Peter's has merged with its upstart neighbour. Also much development along this far-easterly coastline has taken place.

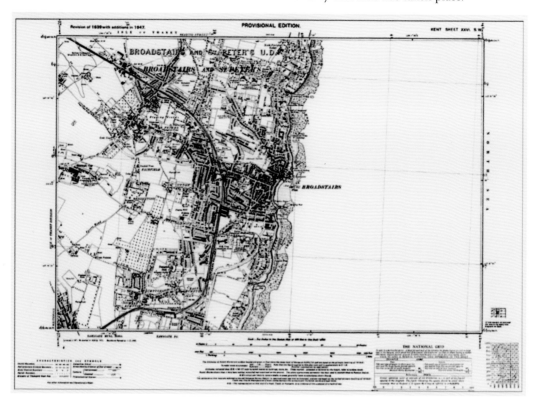

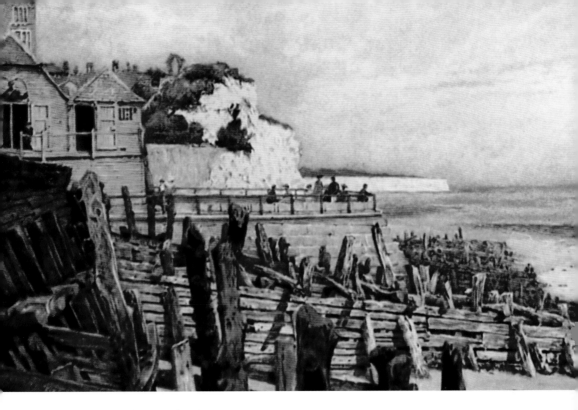

Early Broadstairs
These early images of Broadstairs show its eternally classic features of tall white chalk cliffs standing above broad sandy beaches. There was however, before tourism, little economic activity apart from small-scale marine activity such as boatbuilding, fishing and smuggling.

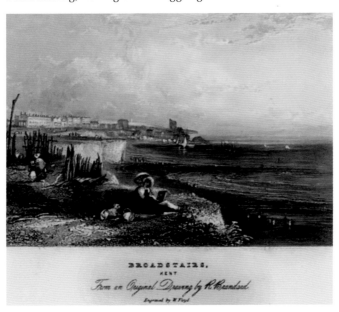

BROADSTAIRS.
KENT
From an Original Drawing by R. Brandard
Engraved by W. Floyd

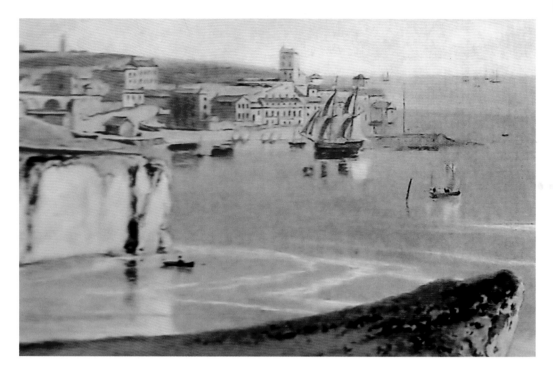

Broadstairs Before 1815

The prints reproduced here show Georgian development and military installations. The population had yet to reach 300 by 1823. The landing pier in the top image was first erected in medieval times and later improved by generations of the Culmer family. York Gate near the harbour was also strengthened to repel potential French invaders.

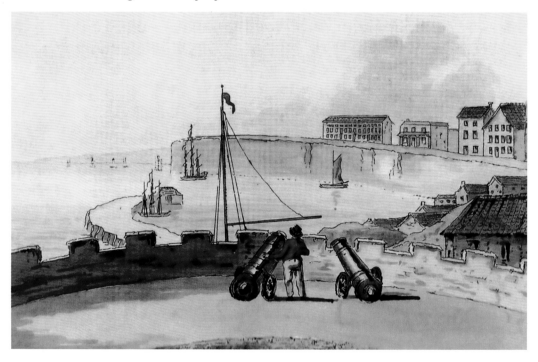

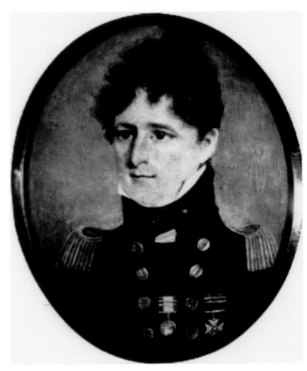

Admiral Austin

Admiral Austin, whose sibling was the famous author, Jane, lived in Albion Terrace, Broadstairs. He was at this time stationed at Ramsgate where he was responsible for raising and organising a corps of Sea Fensibles to protect the Kent coast from French attack. At this time the formidable French Army, under the leadership of Napoleon, had conquered much of the continental land mass and was threatening invasion.

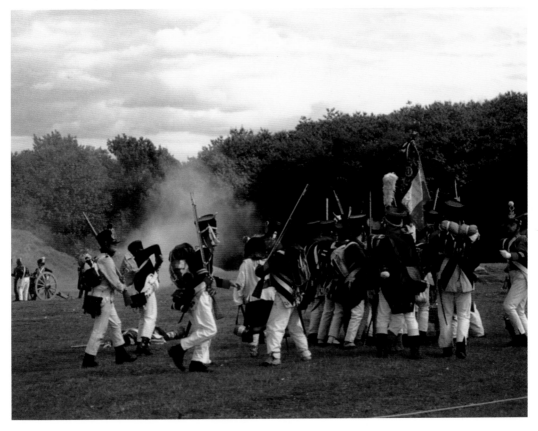

Victory News from Waterloo

20 June 2015 saw the re-enactment on Viking Bay beach of the arrival of Major Percy with the first news of Britain's victory over the French at the battle of Waterloo. One hundred years previously, the message was taken to London by horse-drawn coach along with the enemy's captured eagle standard. A tunnel stairway was built from the beach to the fields above to commemorate this historic event; it was named 'Waterloo Stairs'.

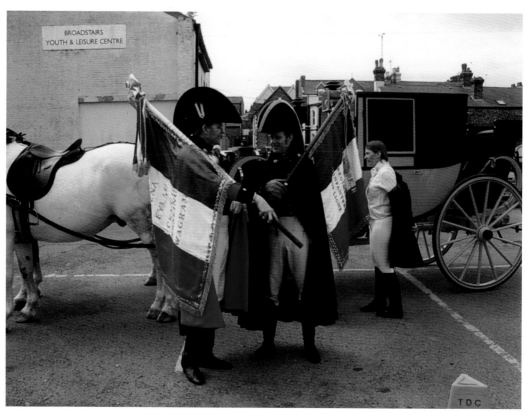

St Peter's I

The village of St Peter's grew after the building of a church there around 1080. It was part of a confederation of towns and villages known as the Cinque Ports. In the case of St Peter's, it was affiliated to Dover. Nearby on the cliff-top was a shrine to Our Lady, and it is from the steps cut into the cliff up to the shrine that the name Broadstairs is possibly derived.

FOLLOWING A SPEECH BY HIS ROYAL HIGHNESS THE DUKE OF YORK AT THE ROYAL ACADEMY IN 1920 ON THE REVIVAL OF VILLAGE SIGNS, THE DAILY MAIL ORGANISED A VILLAGE SIGNS COMPETITION AND EXHIBITION, OFFERING A TOTAL OF £2200 IN PRIZES. TEN AWARDS WERE MADE AND THE DESIGN FROM WHICH THIS SIGN WAS CONSTRUCTED SECURED FIRST PRIZE £1000

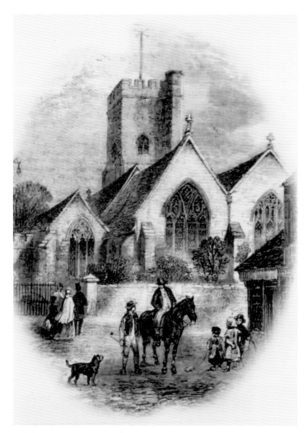

St Peter's II

The handsome flint and stone elevations of St Peter's church replaced an earlier wooded structure. The tower, which contains six bells, was used for naval communication between ships and sending messages along the coastline to military bases; to this day it still retains the right to fly the white ensign.

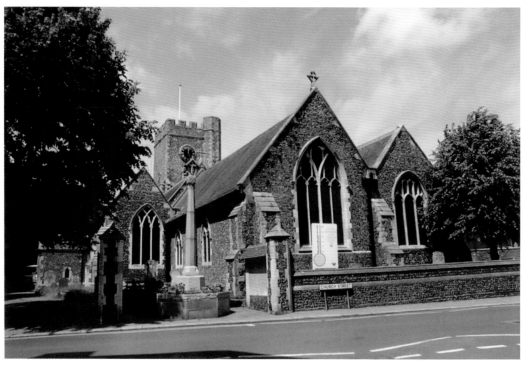

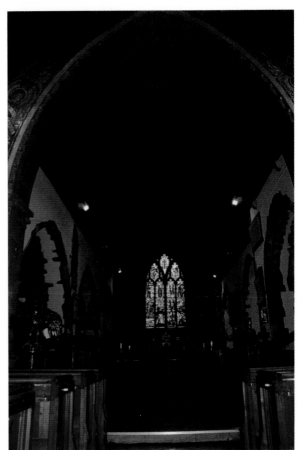

St Peter's III

St Peter's church has a magnificent interior. The highly decorated ceilings and stained-glass windows are a rich endowment. This parish church is also unusual as it has a large 9½-acre burial ground, which contains many interesting characters from British history. It is also the resting place of notable local families, such as the Norwoods who lived at the now demolished Dane Court and the Mocketts of farming fame.

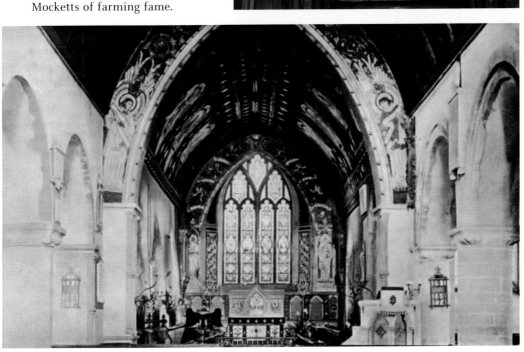

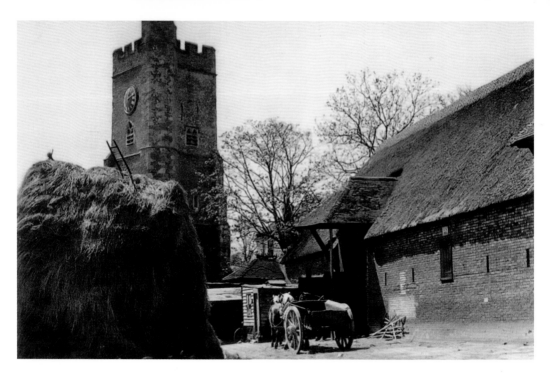

Mockett's Farmyard

Hopeville Farm was acquired by Richard Mockett in the mid-seventeenth century upon his marriage to Sarah Sampson. When he had a new farmhouse erected, their initials were carved in the mellow-red brickwork over the front door. Today this picturesque home looks out on the small village green which was once a farmyard. The old barn illustrated above was destroyed by fire in 1967, but has been sensitively remembered in the outline design for a Co-op store.

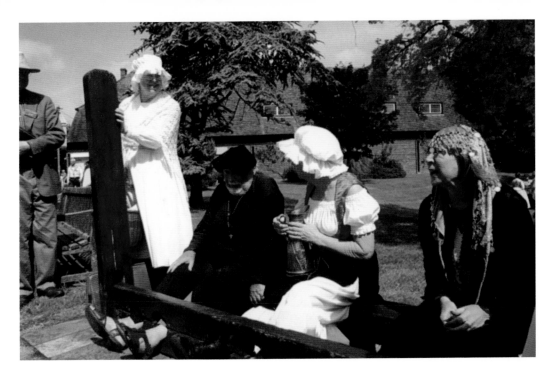

St Peter's Village Tour

St Peter's highly acclaimed village tour is a major attraction for visitors to this area. Locals dress up in Victorian costumes and perform entertaining sketches around the parish. The sketches contain much information about the folklore and history of this fascinating place. Their obvious pleasure is infectious and is best rounded off by refreshment in the local hostelry, the Red Lion.

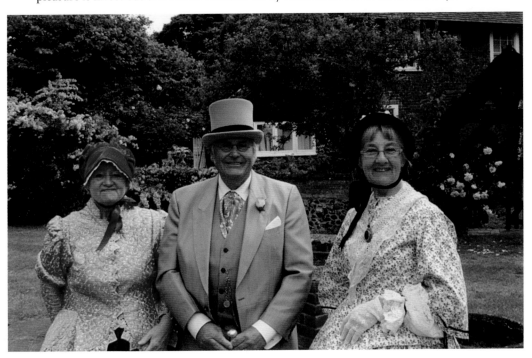

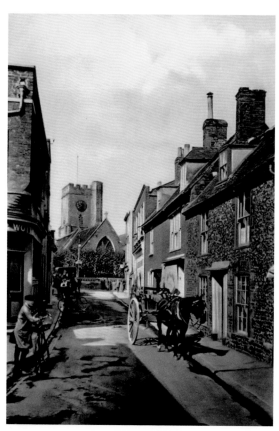

The Red Lion

The present Red Lion public house was built in 1876 and is run by leasehold manager Kim Dickeson. Formerly it was a single-storey building with a thatched roof and was temporarily used as an isolation hospital for victims of smallpox.

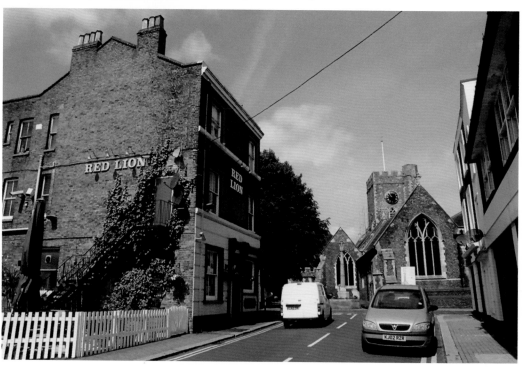

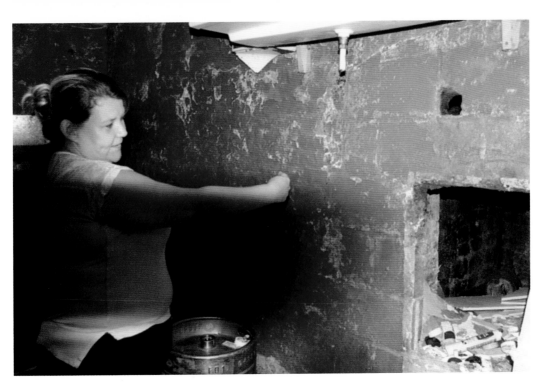

Tunnels and Cellars below the Red Lion

Mel Stanley is shown above describing the tunnels linking the cellar of the Red Lion to the church across the street. It was used for moving dead bodies which had been laid on the stone shelves in the vaults below

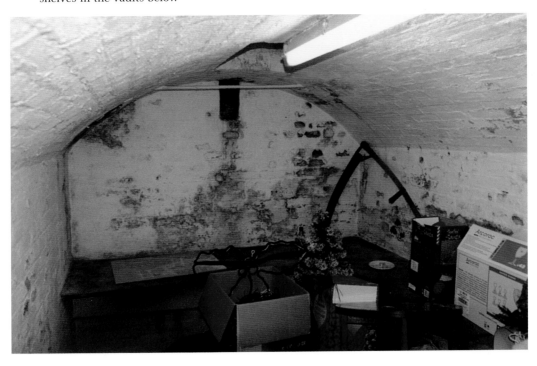

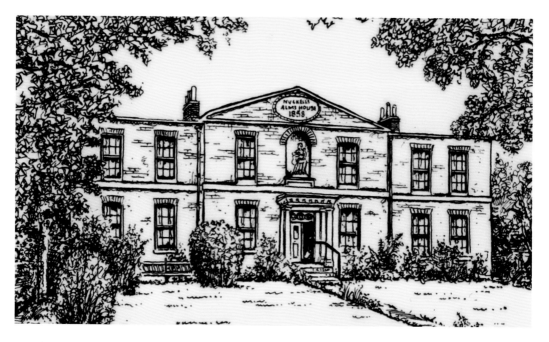

Nuckell's Almshouses

The elegant Palladian-style building on this page was a replacement workhouse paid for by Thomas Brown in 1805. Conditions for inmates were sometimes harsh, particularly when strict rules were not adhered to. Later, when the New Poor Law was enacted in 1834, the structure was converted to almshouses and it remains in this use today – albeit consisting of six self-contained flats.

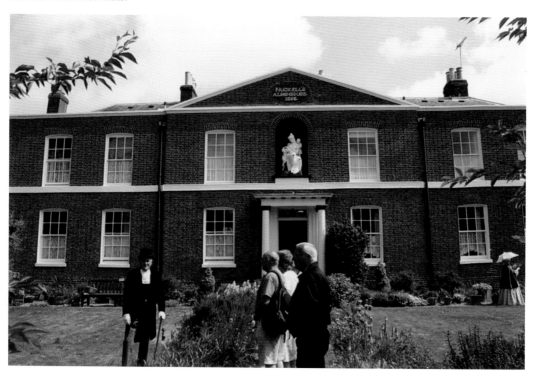

Crampton Tower

Thomas Crampton is one of an exulted breed of Victorians, whose engineering genius and energy contributed to Britain's pre-eminence in the world at the time. Born to a couple who lived in what is now Dickens Walk Broadstairs, Crampton worked with Brunel on the Great Western Railway. Later his career concentrated on locomotive enhancements. His various achievements also included design for a water system in Berlin and an invention of an underground boring machine for the Channel Tunnel, which is still used today. For Broadstairs his lasting memorial is this water tower which, along with a museum, is now open to visitors.

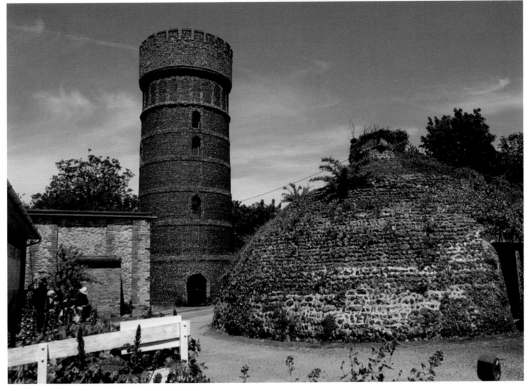

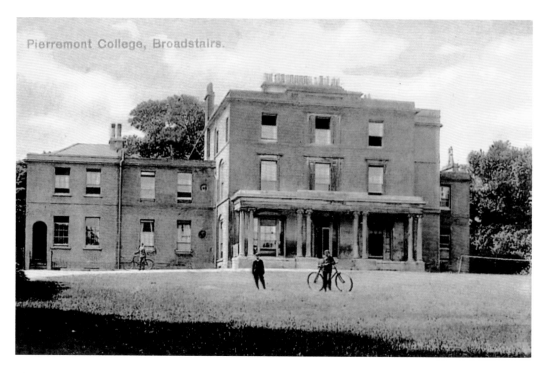

Pierremont College, Broadstairs.

Pierremont Hall

Once a private residence where in 1829 the young princess Victoria spent her summer, this large building became a school and then a municipal centre. After Victoria's visit, gentrification and tourist development began in earnest. Today Broadstairs, like Deal, has a special ambience and this is exemplified by its many festivals and social activities. This year's Food Fair in the grounds of Pierremont Hall is a typical occasion.

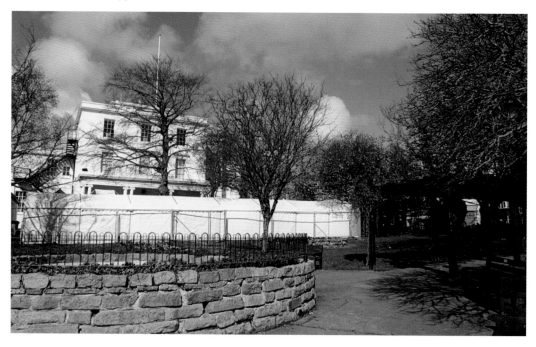

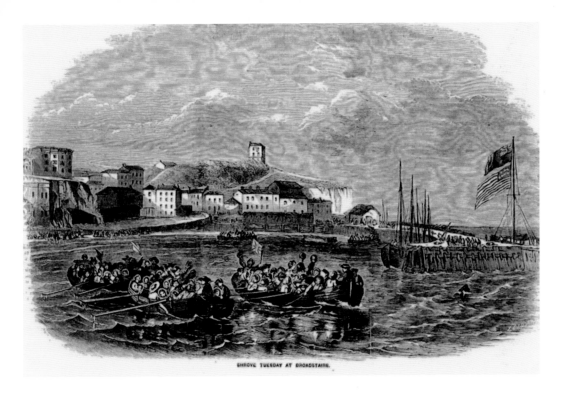

SHROVE TUESDAY AT BROADSTAIRS.

Food Festivals

In 1879 Broadstairs revellers took to the sea to celebrate Shrove Tuesday. They are depicted above overfilling rowing boats with the first multi-storey shoreline buildings shown in the background. The snapshot below was taken in one of the marquees at the town's April food festival.

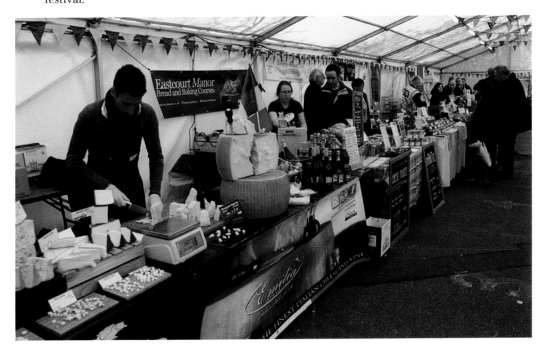

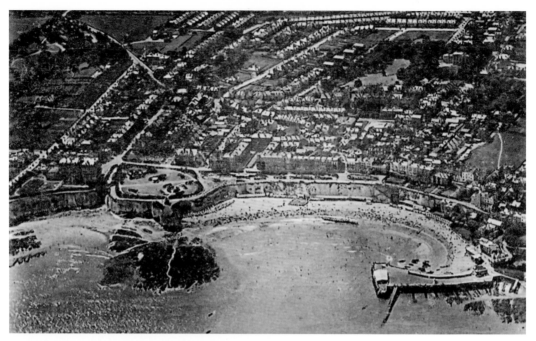

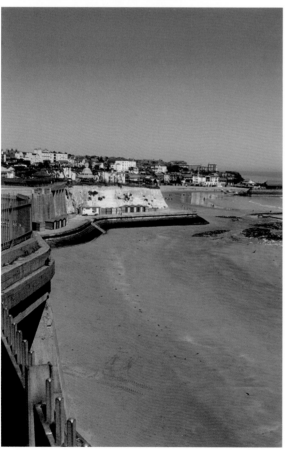

Aerial Photograph
The above shot would appear to
have been taken sometime in the
1930s. It shows the distinctive sweep
of Viking Bay and its signature
chalk cliffs. This densely populated
beach contrasts with the deserted
contemporary landscape picture of
Louisa Bay looking northwards.

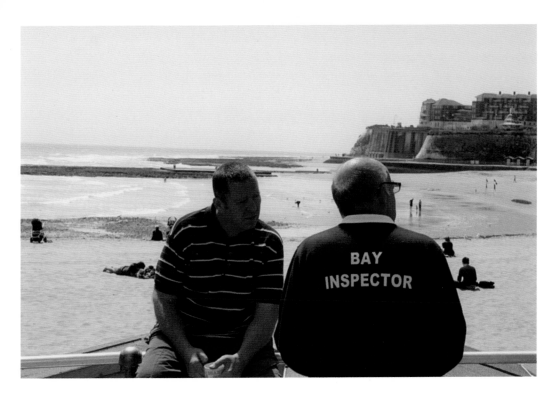

Bay Inspectors

Bay inspectors are responsible for displaying the times of high and low tides, as well as other duties that contribute to the management of beaches. Their work has contributed to blue-flag awards. Below, an atmospheric sepia picture from a century ago shows these sands enjoyed in an unregulated way.

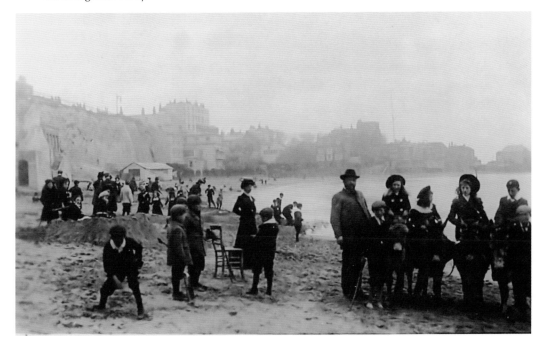

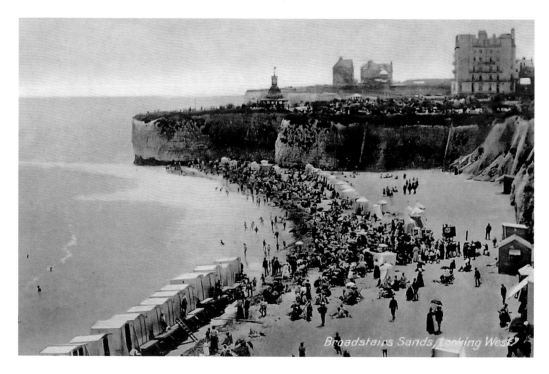

Broadstains Sands, Looking West

Fun on the Sands

These before and after shots of Viking Bay looking west show vastly different approaches to fun at the seaside. Above, bathing machines are de rigeur with their elaborate method of providing a mobile changing room and steps into the surf. Below, apparatus for children's amusement are currently the only mechanisms to be found here.

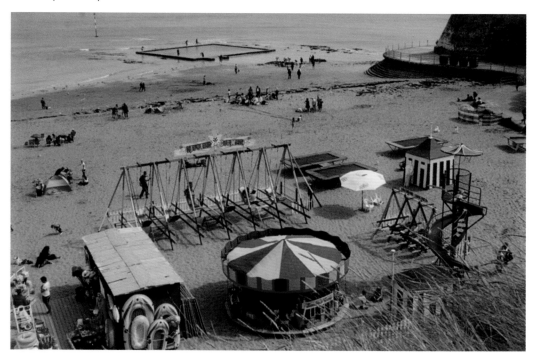

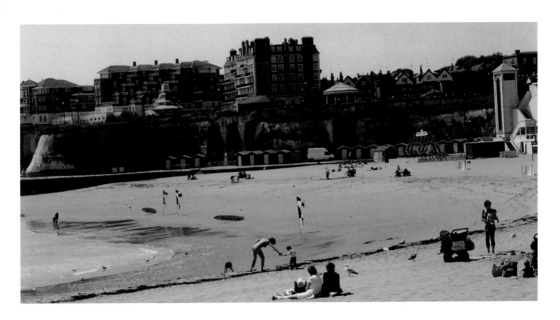

Grand Hotel

Prominently placed above Broadstairs is Grand Mansions. This was once the magnificent Grand Hotel which was built for Mr John Butterfield in 1882. Postcards such as the one below were provided for the use of residents in its Edwardian heyday. Then dress-code was very strict and evening diners had to be suitably attired. Ted Heath, local musician and future political leader, was known to play piano here in his youth.

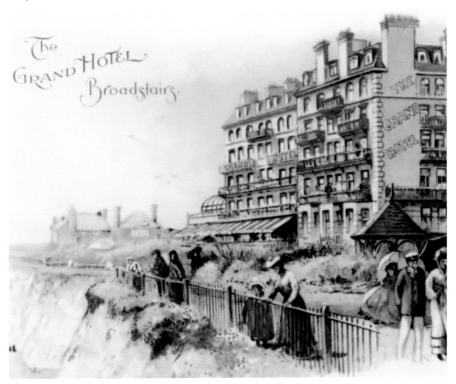

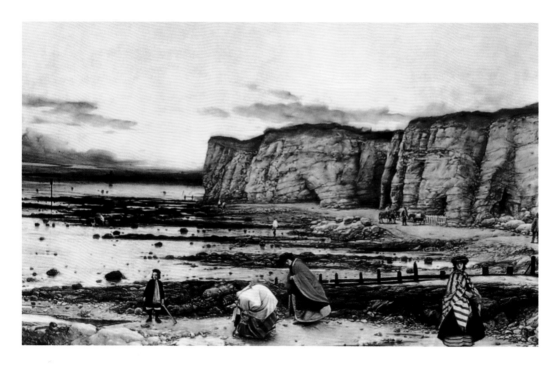

Viking Invaders

In AD 449 Viking invaders landed on the Kent coastline at Thanet having travelled from Denmark. This journey, led by Norsemen Hengist and Horsa, was replicated in 1949 by a crew of mainly amateur sailors. Their craft has been preserved above Pegwell between Broadstairs and Ramsgate.

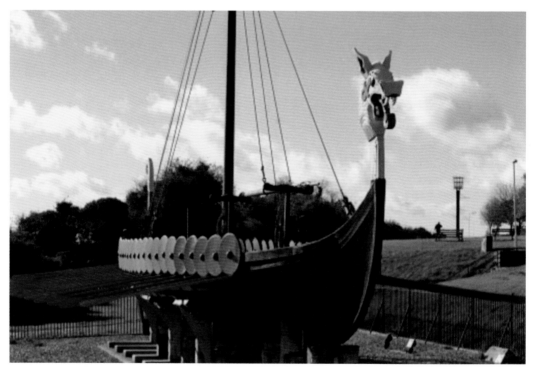

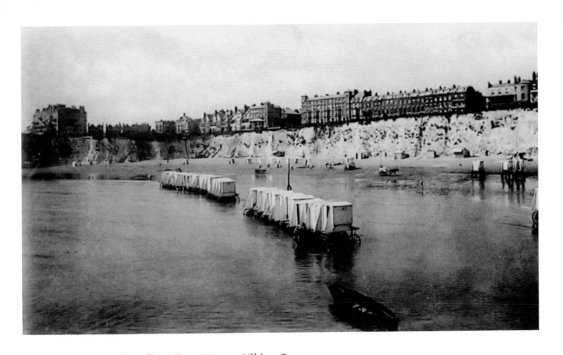

Westward Edwardian Views Across Viking Bay

Above a scene of smart Edwardians on the jetty is juxtaposed with a more distant shot of bathing machines and elegant, respectable holiday-lodging houses or hotels. This was before cheap flights to distant resorts were heard of and only the moneyed middle classes could afford a proper holiday

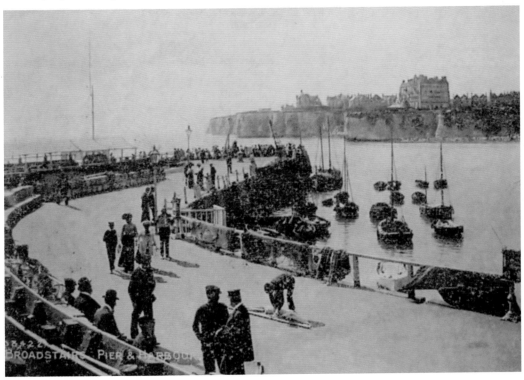

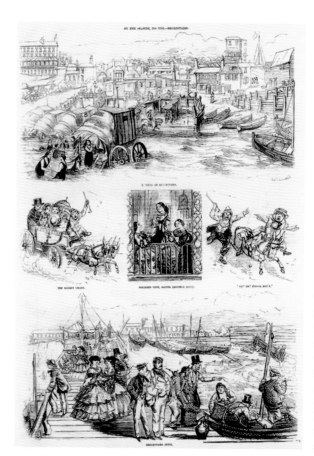

Period Dress for the Seaside

The Victorians were well known for overdressing, with a penchant for crinoline dresses, silk top hats and expansive waistcoats. This phenomenon continued into the early twentieth century with this classic period photograph below showing of a party of two couples kitted out for a day on the beach at Broadstairs with stripped blazer, spats and bow ties.

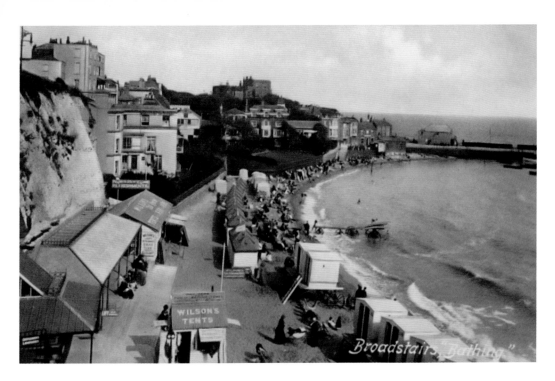

Viking Bay Looking Eastwards

As in previous pages this part of the beach is also less-densely populated by bathers today. Bathing machines have disappeared although their rotting remains were still seen within living memory. New innovations include lifeguard stations and coloured flags to indicate safe swimming area parameters.

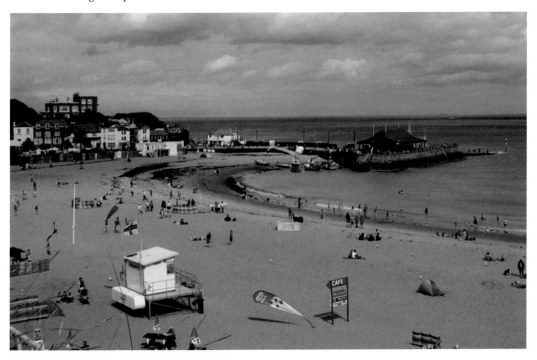

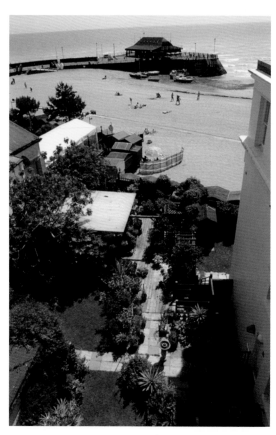

Garden Splendour
This striking, attractively designed and well-cultivated garden arrests the eye walking along the Eastward promenade towards the harbour. Its more lofty trees and shrubs cut the skyline even at beach level.

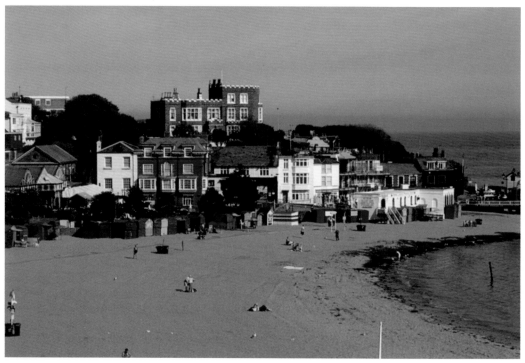

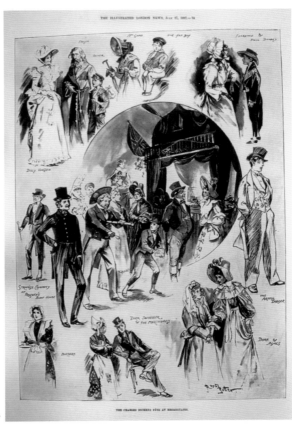

Charles Dickens Festival, Broadstairs

Charles Dickens loved to visit Broadstairs so much so that he described it affectionately as 'our English watering place'. From his early successful writing of *The Pickwick Papers* to his later *David Copperfield*, the town and its characters brought him inspiration. His close links are annually celebrated with the Broadstairs Dickens Festival. Below, a dedicated member of the organisers busies herself setting up a stall on the promenade, selling programmes of events.

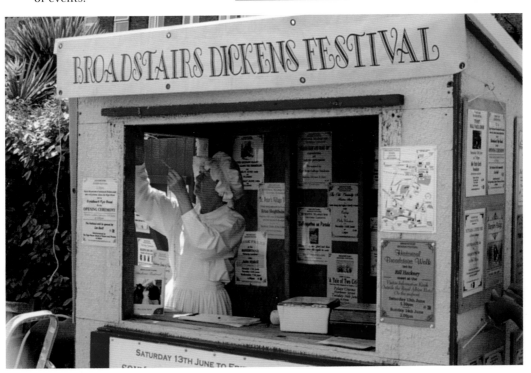

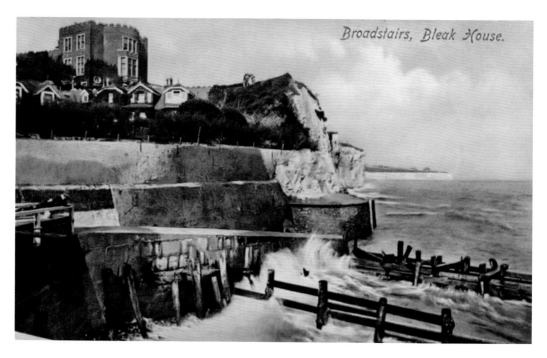

Bleak House

Originally called Fort House, this was the residence of a captain of one of the two forts guarding Broadstairs. The major domo of English literature, Charles Dickens, spent his summer holidays here in the 1850s and 1860s. There is some dispute however as to whether this is the actual Bleak House referred to in his novel of 1853.

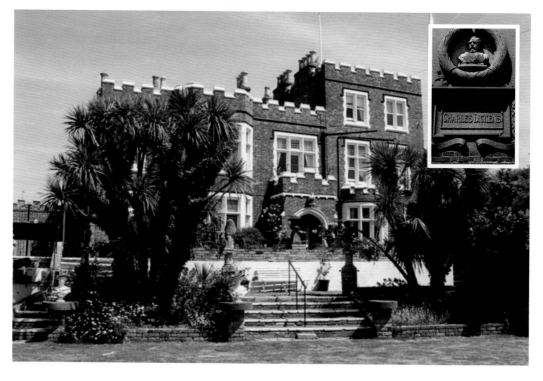

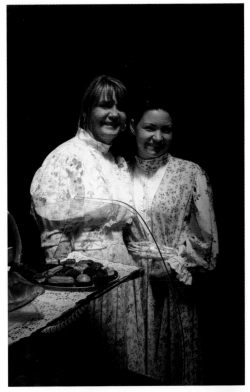

Bleak House Museum and Hospitality

Until 2012 Bleak House had a dual role as a private residence and a museum for visitors to appreciate its strong association with Dickens. Its present owners offer guided tours of the fascinating rooms, led by Debbie and Nicola dressed in period costumes, as featured in the top image. Furthermore, facilities for functions such as weddings are now provided for in grand chambers full of character furnishings. The most poignant spot is the raised dais where the great Victorian author penned his most famous work (*David Copperfield*), which echoed his lifetime childhood experiences: being brought up by a feckless father and a somewhat emotionally remote mother.

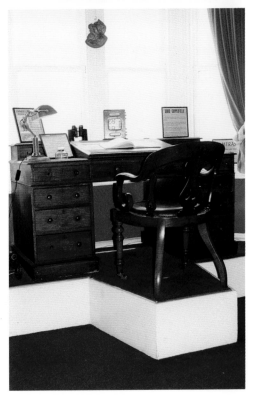

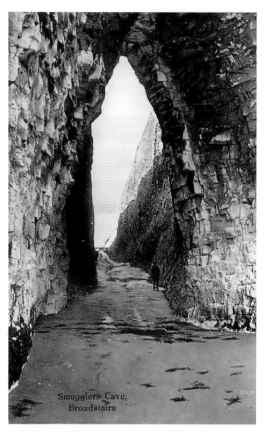

Smugglers Cave,
Broadstairs

Smuggling

Smuggling was so rife along the Kent coastline that when Daniel Defoe visited the town he reported that it was obvious that this illegal activity must have economically supported a large proportion of its population. High taxes on imported goods from the continent, such as spirits tobacco and lace, meant that these goods were secretly landed and hidden in easily excavated chalk tunnels before distribution. The pictured recreation of a smuggler's tavern is set up in the cellars below Bleak House and is included in its guided tour.

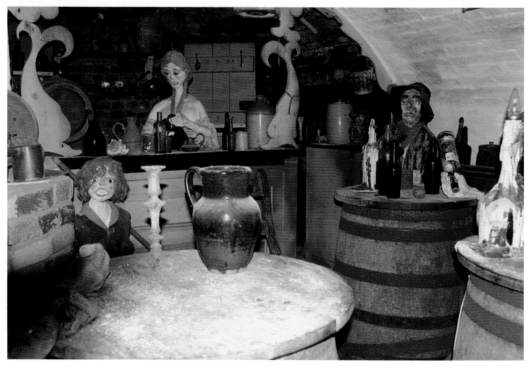

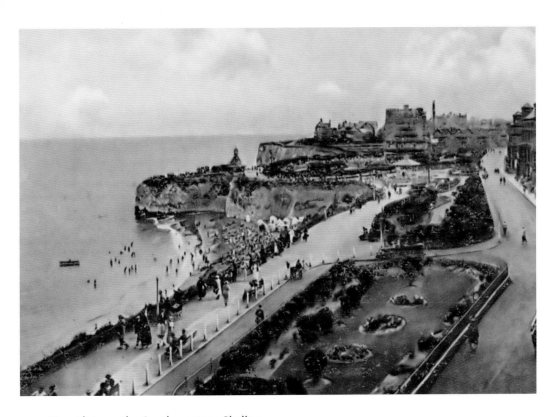

New Flats on the South-western Skyline

After comparing the two images on this page it is clear that the major difference, apart from the intensity of human activity, is the high-rise flats on the south-western skyline of Viking Bay. They match the massive scale of Grand Mansions, but fortunately do not attempt in their design to be any kind of Victorian pastiche.

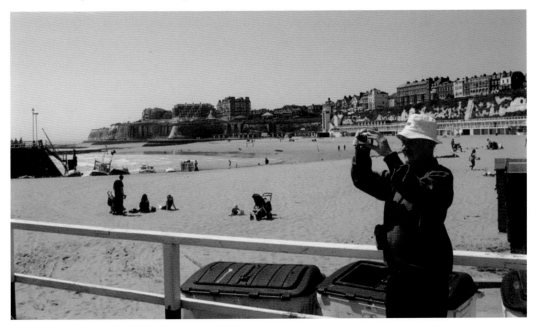

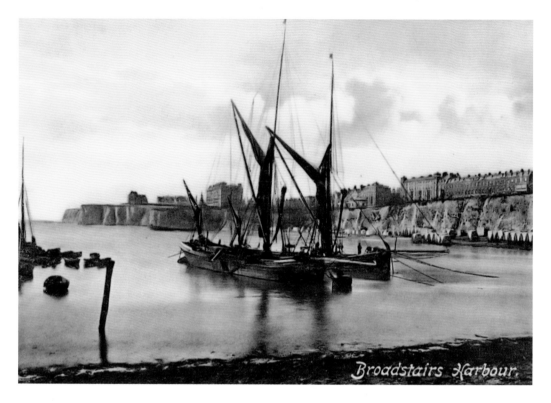

Sailing Barges, Broadstairs Harbour

Once the equivalent of the modern-day articulated lorry, Thames sailing barges were a prolific means of coastal transport for heavy goods. They conveyed around a hundred tons of cargo and were demanding craft to manoeuvre in shallow tidal waters such as Broadstairs harbour. Today, the largest vessels seen here are a part of a small fleet of fishing boats.

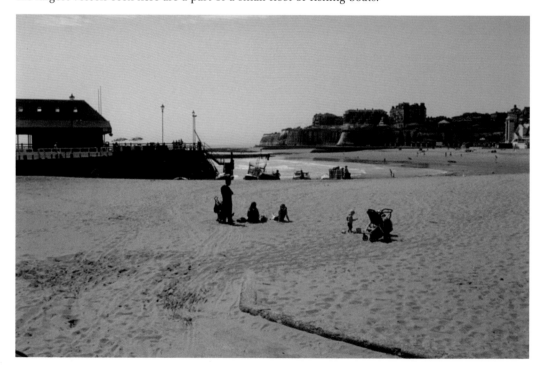

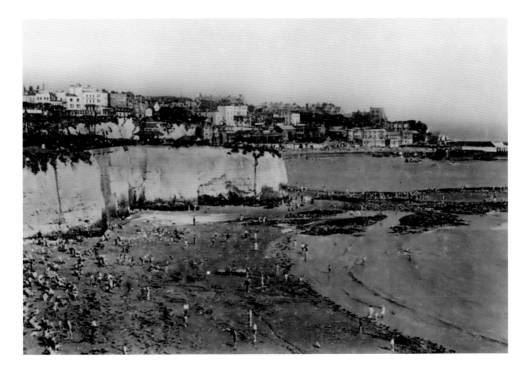

Decline in Popularity of the English Seaside Resort

Many of the image comparisons within this volume, which has deliberately concentrated on Broadstairs' magnificent beaches, portray a less popular desire of the British to spend their holidays on the English coastline. As mentioned previously, cheaper travel costs, reliable foreign weather and higher living standards are all contributory factors – not least the shrinking of global remoteness and information of overseas destinations provided by the media and internet. There is however, a perceptible revival in Thanet and arguably the unique qualities of Broadstairs have been passed down through the warm nostalgia of generations of happy holidays spent there.

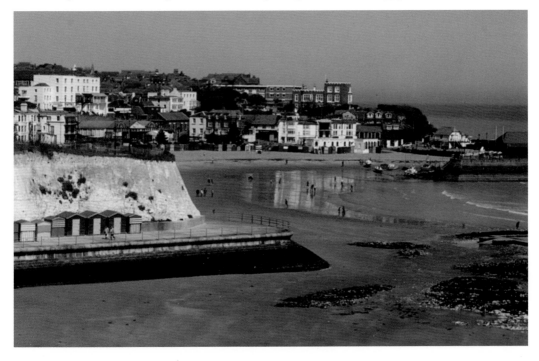

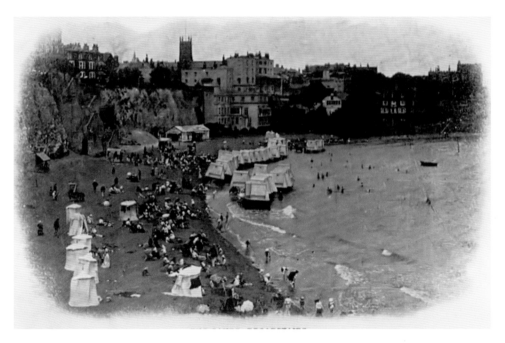

Coastal Defence Works, Louisa Bay

Solid and costly concrete defence works have, over recent years, been built along the cliff bottoms of Louisa Bay. Not only do they prevent erosion, they are also a convenient pathway and base for changing huts, as depicted below.

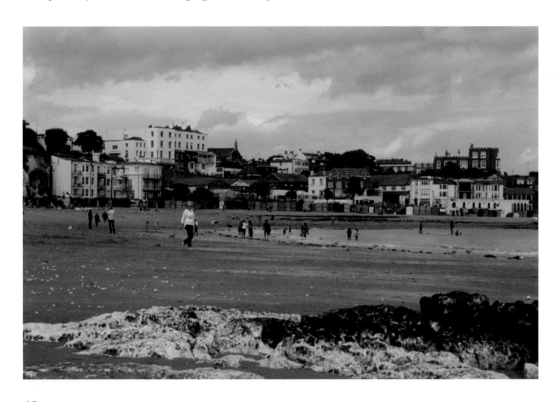

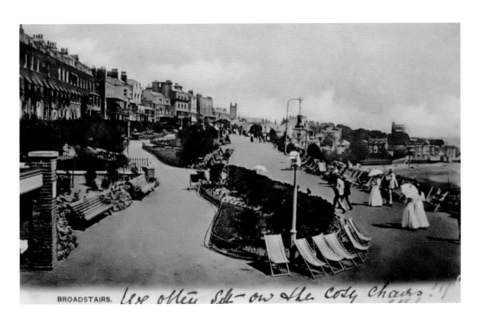

BROADSTAIRS. *Lex often Shh—ow the cosy chairs!!*

Promenade I

Unchanging grace and elegance of the promenade above the beach has been a much-loved feature of Broadstairs for generations. The archive images here show deckchairs staked ready for visitors and a bandstand awaiting musicians to entertain.

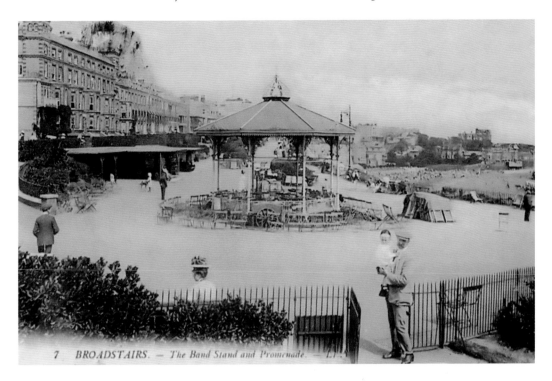

7 BROADSTAIRS. — The Band Stand and Promenade.

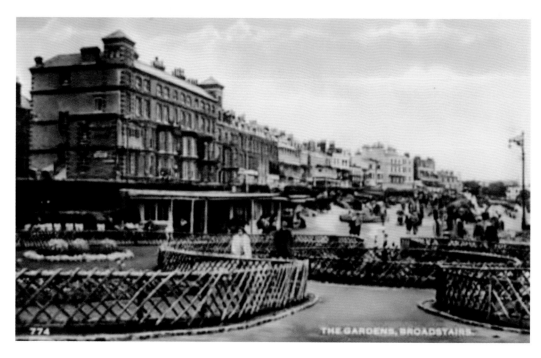

THE GARDENS, BROADSTAIRS.

Promenade II

Municipal authorities have always showed great attention to the gardens along the promenade. Hedges are kept trim and borders burgeon with colourful planting schemes.

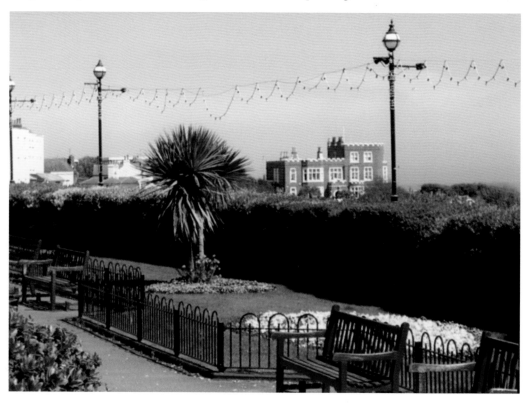

Paddling Pool

With a wide tidal range in Viking Bay, its paddling pool provides immediate safe bathing facilities for children at all times. It has existed for many years, but was restored in 1988 as part of a Manpower Services Commission Community Programme, and officially opened by Broadstairs' Mayor Councillor, Mrs Peggy Marchant.

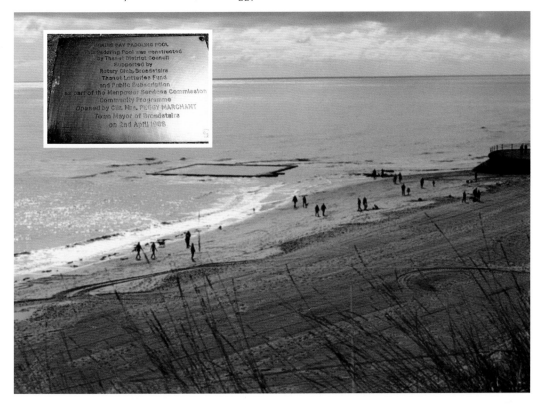

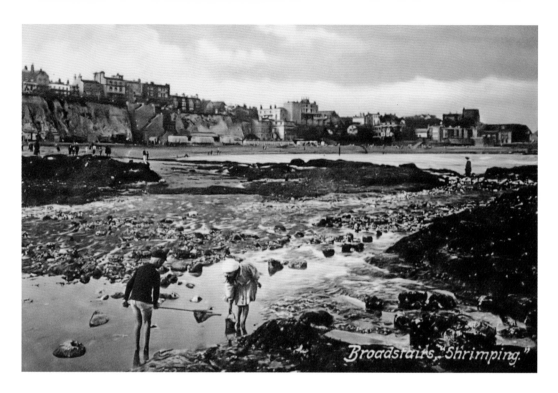

Rock Pools

The porous nature of the chalk coastline at Broadstairs has produced endless possibilities for children to indulge in rock pooling. Cavities of warm brine contain all sorts of miniature sea creatures, but shrimps and crabs are particularly sought after.

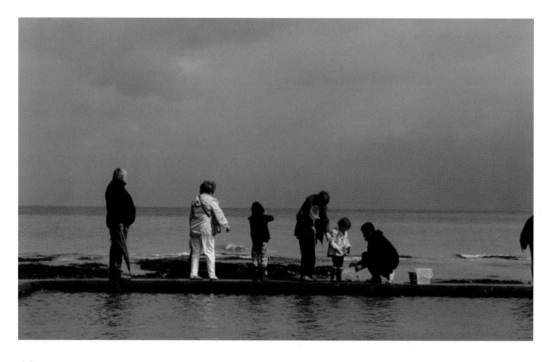

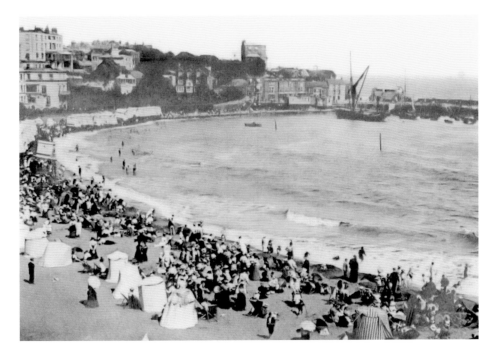

Unchanging Broadstairs

The comparative pictures on this page clearly illustrate how little time has affected the glorious vision of Viking Bay. In general the whole town's individual character has been compared to Cornish resorts with its winding narrow streets, friendly locals and exceptional quality of ice-cream offerings.

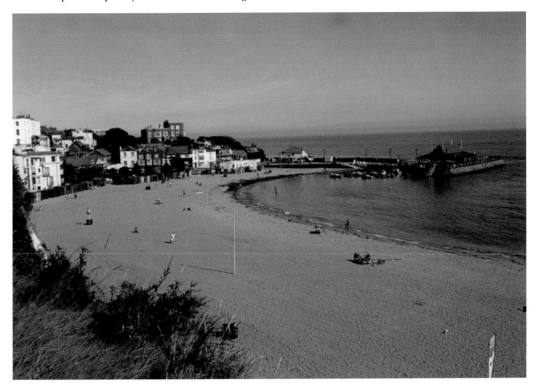

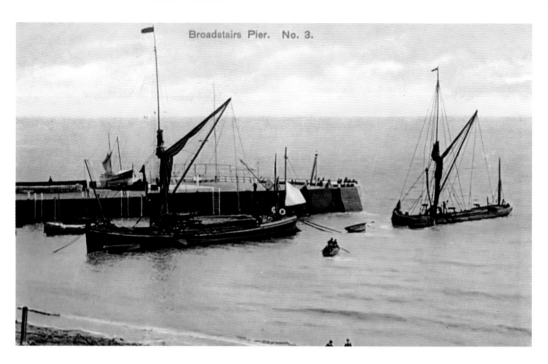

Broadstairs Pier

The old postcard view above illustrates a bare pier-end of the harbour, where only the lifeboat sits in readiness. In April 2015 the scene has changed to one where leisure dinghy sailing is in progress and umbrellas are raised above tables set out for sporting refreshment.

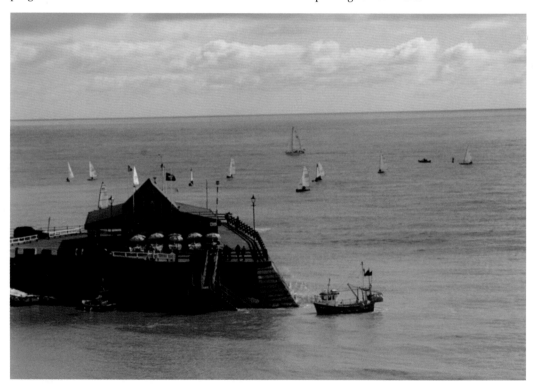

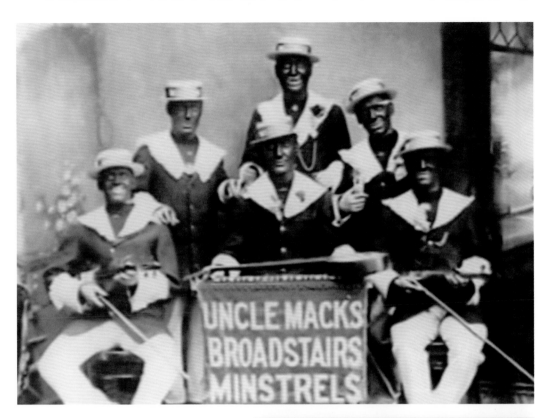

Uncle Mack

James Henry Summerson, aka Uncle Mack, brought his particular brand of entertainment to thousands of Broadstairs holidaymakers over a long career. His blackened face is no longer considered politically correct and, like the television programme *The Black and White Minstrels*, has disappeared into a past epoch. The plaque below, which is placed on the promenade, commemorates his happy life.

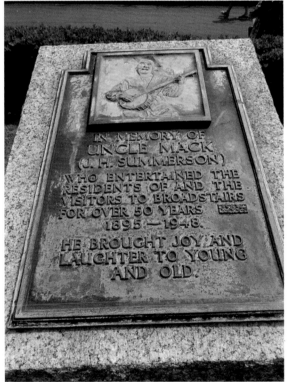

IN MEMORY OF
UNCLE MACK
(J. H. SUMMERSON)
WHO ENTERTAINED THE
RESIDENTS OF AND THE
VISITORS TO BROADSTAIRS
FOR OVER 50 YEARS
1895 – 1948.
HE BROUGHT JOY AND
LAUGHTER TO YOUNG
AND OLD.

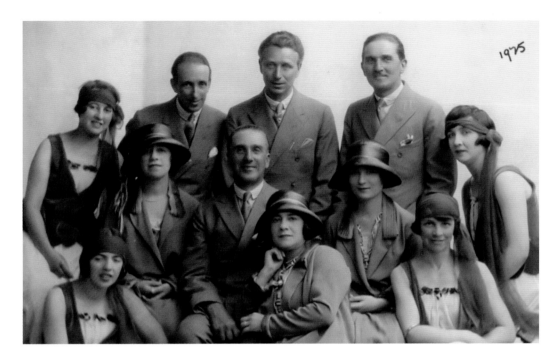

1975

Concert Parties

Before the age of television, live entertainment was far more popular. In the pre-war years, bands of professional performers would tour seaside resorts. The portrait pictures featured are of two anonymous troupes that are known to have worked at Broadstairs.

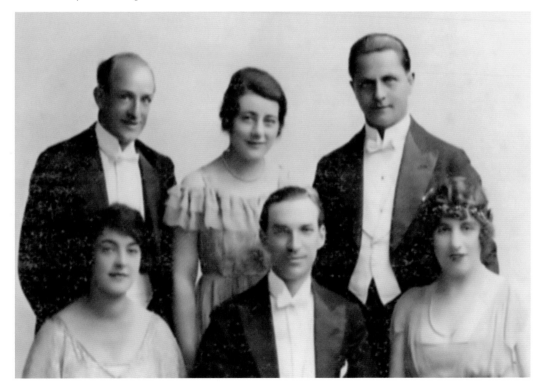

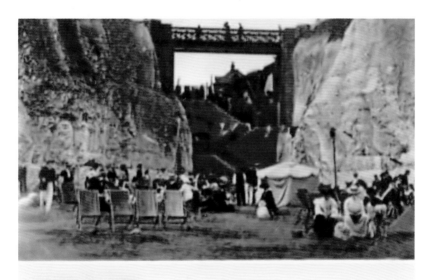

Louisa Gap, Broadstairs

Louisa Bridge

The original Louisa Bridge was built by Broadstairs' famous engineering son Thomas Crampton in 1850. As part of other major coastal-defence improvements it was rebuilt in 1994.

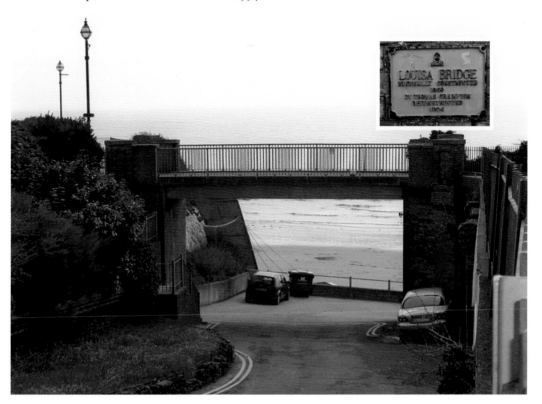

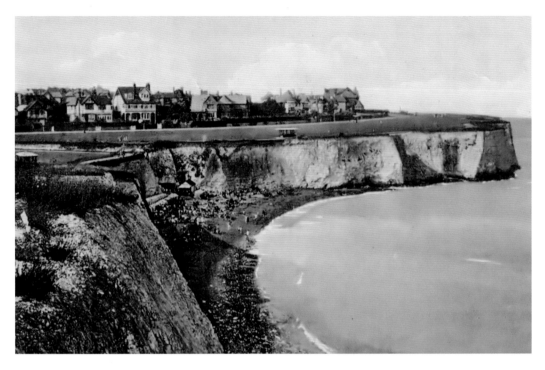

Dumpton Gap

South of Louisa Gap and Viking Bay lies Dumpton Gap and beach. With the same soft sand and shallow bathing facilities it has always nonetheless been slightly less commercial than the former. There was however a healthy number of visitors when these old postcard images were taken.

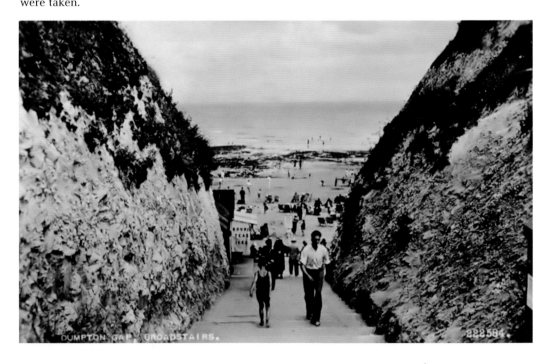

Dumpton Bay Promenade
There is a lofty, breezy exclusivity to the substantial villas perched above Dumpton Bay. The homes here represent some of the grandest in design and scale that the town has to offer.

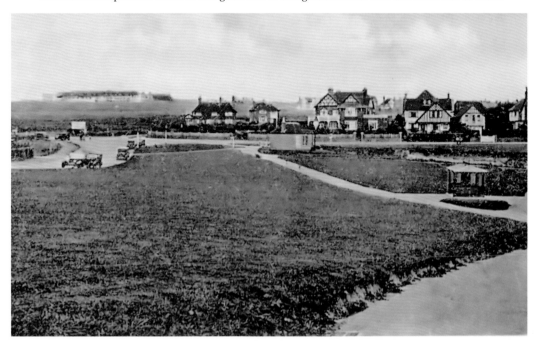

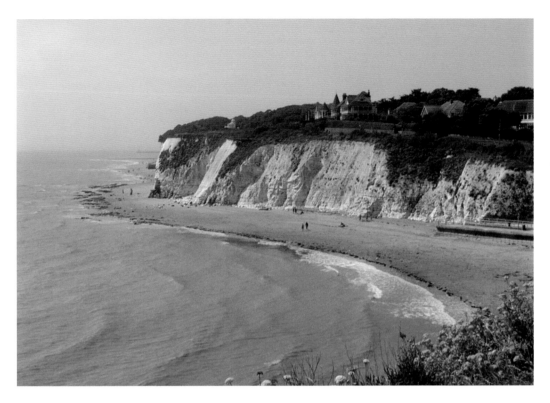

Thanet Coastline

The Thanet coastline is one of the most valuable areas in England for marine wildlife. The area is also of great geological interest. At Dumpton Gap there are some fine examples of chalk cliffs with several sea caves. On the cliffs wild flowers grow in profusion, including many uncommon varieties.

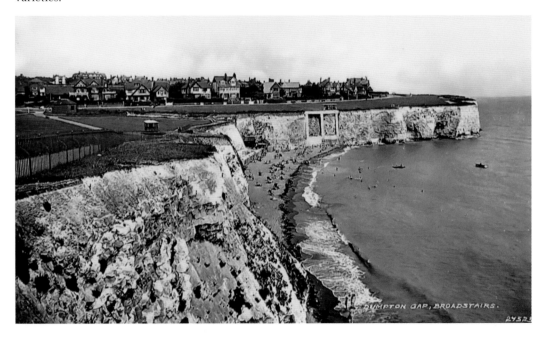

DUMPTON GAP, BROADSTAIRS.

24525

WE'RE WAITING FOR OUR SHIP TO COME IN AT BROADSTAIRS.

Seaside Postcards I

An alteration in the law in 1894 permitted the Royal Mail to allow postcards to be sent through the post. This was at a time when steam locomotives, providing fast affordable travel, meant the seaside was a popular tourist destination. Consequently this spawned a souvenir industry and postcards were produced to fill this generated demand.

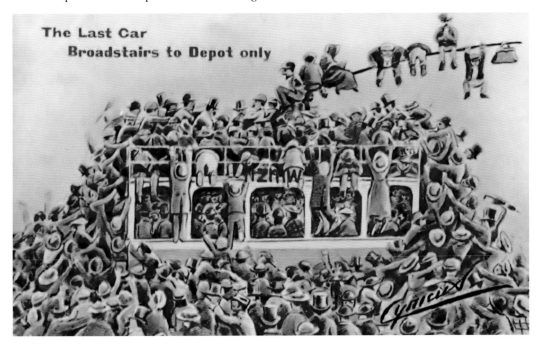

The Last Car
Broadstairs to Depot only

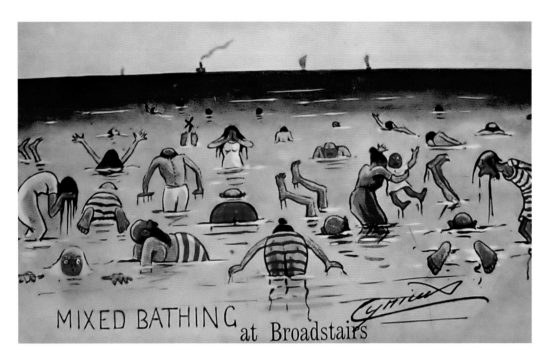

MIXED BATHING at Broadstairs

Seaside Postcards II

In the 1930s cartoon-style postcards became widespread, and at the peak of their popularity the sales of saucy postcards reached a massive sixteen million a year.

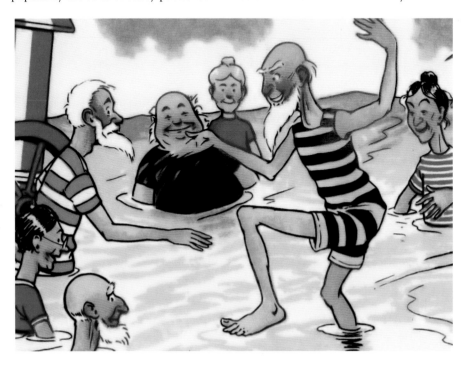

Crested China

Crested china as a seaside souvenir was the invention of W. H. Goss. With his two sons, Adolphus and Victor, he produced these ornaments in his Falcon Stoke-on-Trent pottery. They bear towns' crests above place names and are typically in the shape of Roman and Greek antiquities. Most Edwardian homes contained at least a few of these little china items, but they went out of fashion in the interwar years.

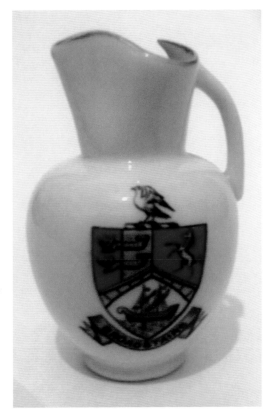

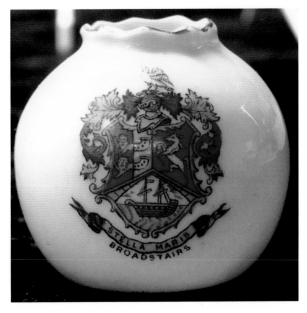

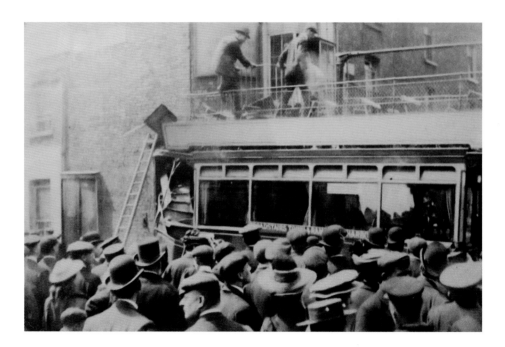

Trams

The Electric Tramways and Lighting Co. Ltd opened a line between Ramsgate, Margate and Broadstairs on 4 April 1901. The 11 miles of track were one of the few inter-urban tramways in Britain owned by a private company and running through open countryside between three towns. Most of this area is built over now, however much of the route was on its own right of way, and this only became public road when the tramway was abandoned. Competition with fully enclosed buses contributed to its demise, but summertime travellers revelled in the open-top journeys.

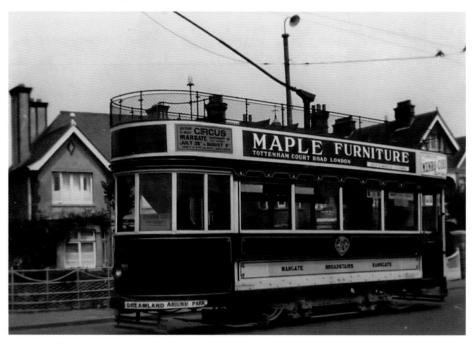

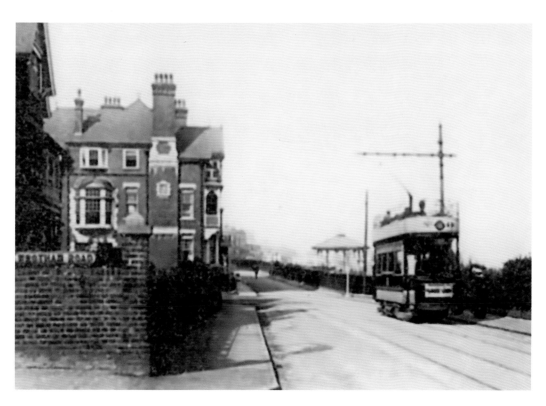

Esplanade

The postcard picture above depicts a tram in action along the esplanade. Below, a busier scene on 4 July 2015 shows stallholders preparing for a fete. In the far background, funfair equipment is set up on the green below Grand Mansions.

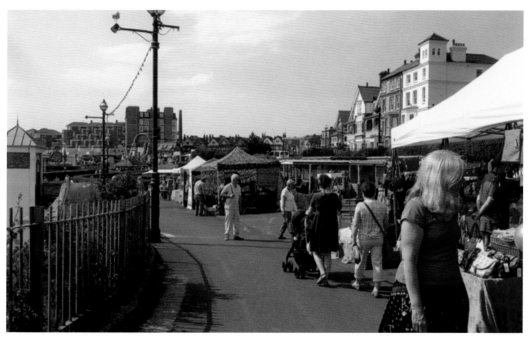

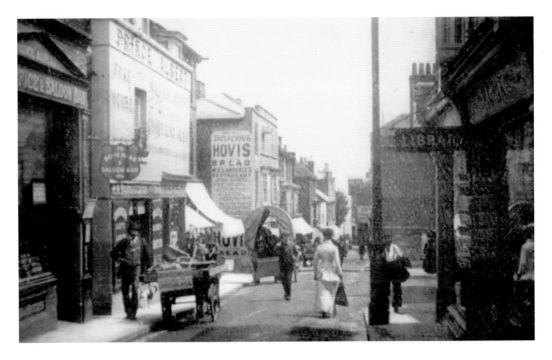

Before the Age of Motoring

The tranquil scenes on this page are of an age before motor transport became of any great significance. Horse-drawn vehicles dominated and pedestrians were able to use either the pavement or road with impunity. Formal dress was normal and gentlemen felt incomplete without walking canes, as did ladies without sun parasols.

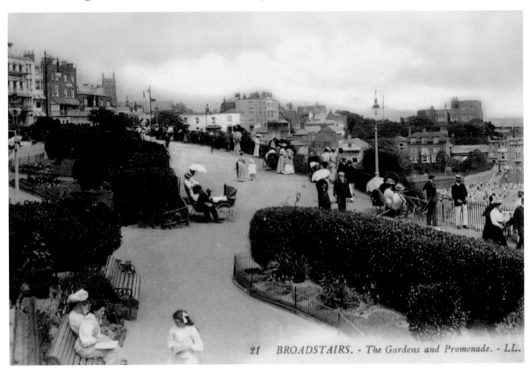

21 BROADSTAIRS. - The Gardens and Promenade. - LL.

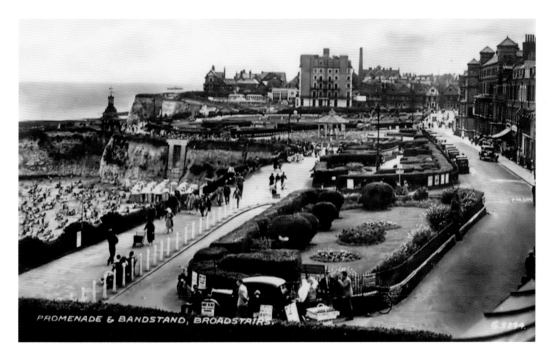

PROMENADE & BANDSTAND, BROADSTAIRS

Promenade Exercise

The sight of a recreational jogger in shorts and running shoes would have attracted attention in the 1930s when this now widespread activity was confined to serious sportspeople only. Taking in the sea air while strolling along the clifftop was the normal practice then. Fortunately, the segregation between cars and pedestrians in this key area continues today.

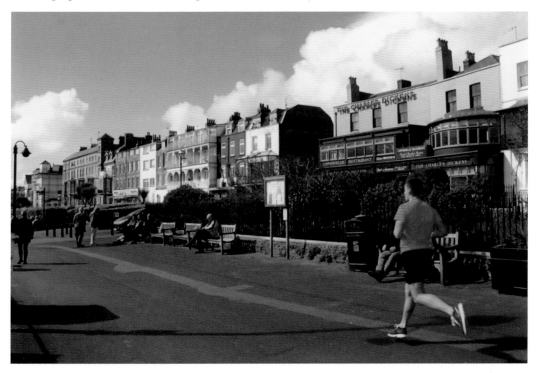

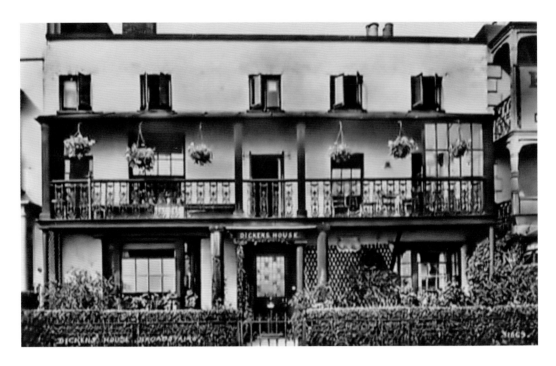

Dickens House Museum

This listed house on Victoria Parade was the inspiration for Charles Dickens' home of Betsey Trotwood in his novel *David Copperfield*. His fictional description closely resembles his friend Miss Mary Strong's home, with its gravelled garden filled with flowers and a parlour furnished with old antiques. Now a museum of Dickens artefacts, it is run by volunteers from the Dickens Fellowship. In 1973 Dora Tattan left the property in her will to the town and it is looked after according to her wishes.

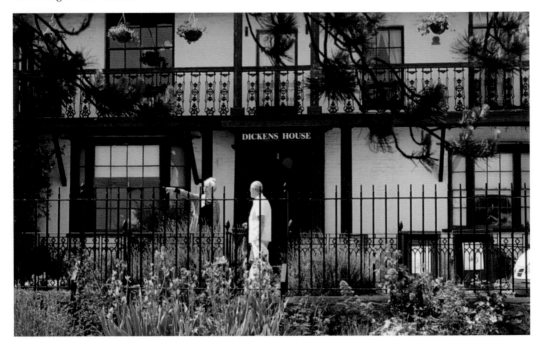

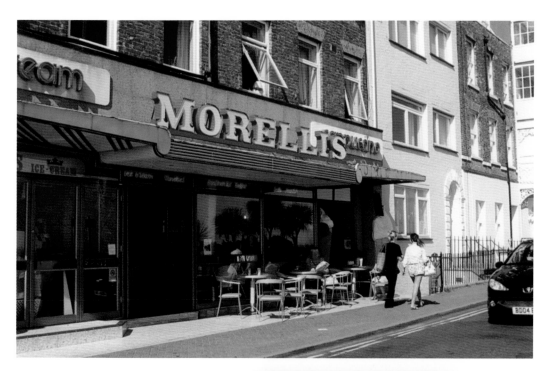

Morellis

Arguably the best ice-cream in the world is produced by Morellis. Their parlour at Broadstairs was opened in 1932 and upgraded in 1959. It is a classic example of Art Deco design with even its potted plants (hydrangeas) the correct shade of matching pink. The author is a long-term satisfied customer from when his parents rented a holiday home near Grand Mansions. His favourite order remains a Knickerbocker Glory – sadly the price is no longer half a crown.

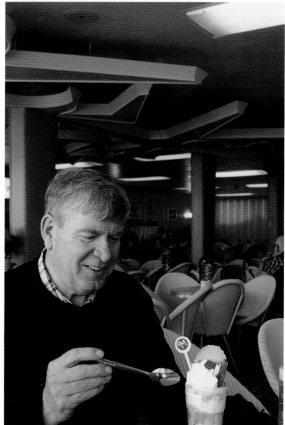

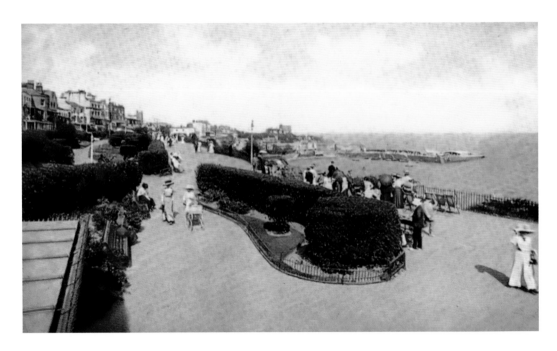

Promenade Palms

Due to global warming, tropical palms have now become a part of municipal planting schemes. The snapshot below shows them establishing themselves amid more traditional clipped evergreen hedges. Morellis ice-cream parlour's prominent frontal position can also be appreciated from this present landscape.

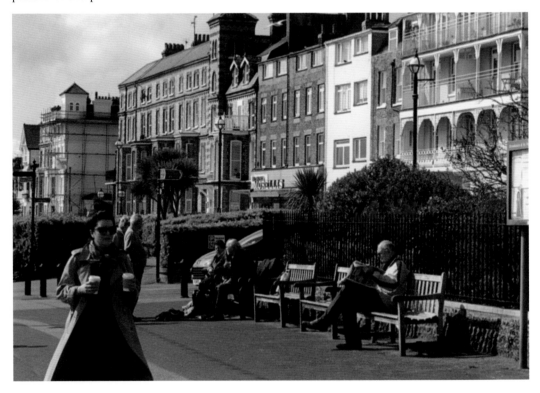

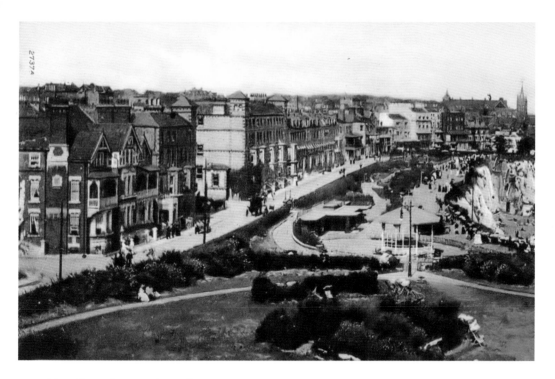

View from the Grand Hotel

The prospect of genteel Broadstairs in the early twentieth century is encompassed in the postcard image above. Looking from the opposite direction today at the luxury flats that have been built next to Grand Mansions, there is no doubt that the unspoilt charms of the town have continued to prove worthy of their premium values.

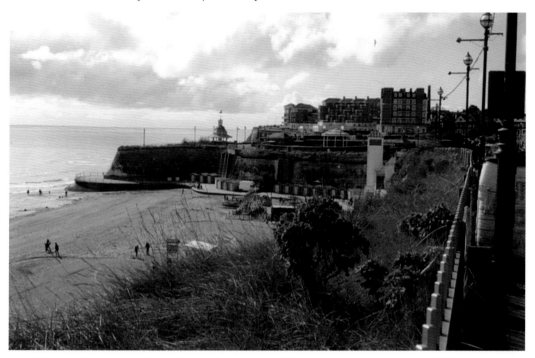

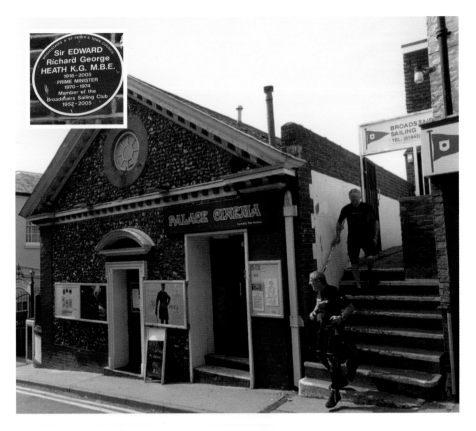

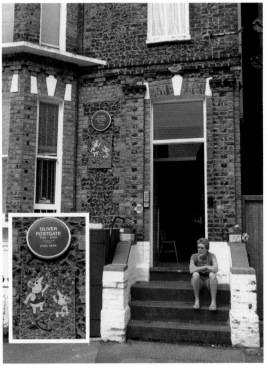

Broadstairs' Famous Personalities

Broadstairs has, over the years, attracted many famous personalities from the world of entertainment and the arts. Perhaps its most notable home-grown resident was Edward Heath who became Prime Minister. He was brought up in relatively humble circumstances at St Peter's. Following senior school in Ramsgate he won a scholarship to Balliol College, Oxford. The above photograph illustrates his love of sailing engendered from Broadstairs' sailing club next to the town's diminutive, but nevertheless popular, cinema. Below Oliver Postgate, originator of beloved children's-story characters such as Bagpuss, lived in Chandos Square, which historically was the site of a gun battery.

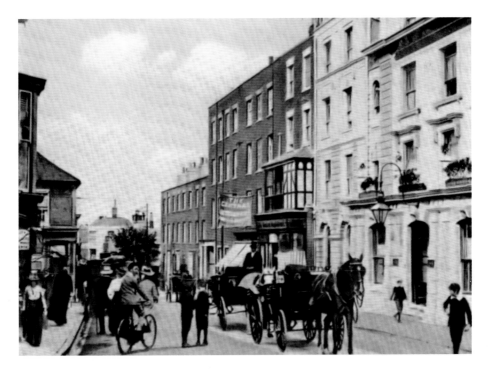

Albion Street

At the heart of historic Broadstairs is Albion Street where, currently, a four-bedroomed regency house is offered for sale at £900,000. This handsome terrace has remained relatively unmolested by 'modernisers' and is next to the smart Albion Hotel.

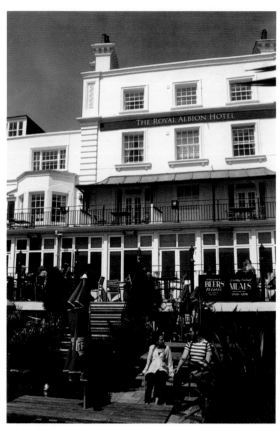

Royal Albion Hotel
Built as a residence in 1776 the
Royal Albion hotel, with twenty-one
bedrooms, was once the residence of
Charles Dickens. Many other famous
guests have stayed here and enjoyed its
excellent food.

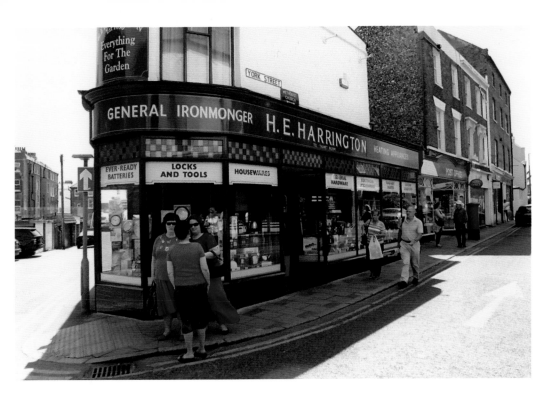

Broadstairs Shops I

Out of the many quirky independent stores in Broadstairs, one of my favourites is H. E. Harrington, Ironmonger. This shop is run by Henry Harrington, who has fifty-eight years of service. He is one of a dying breed.

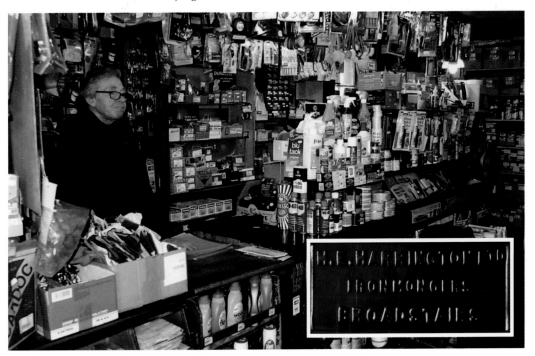

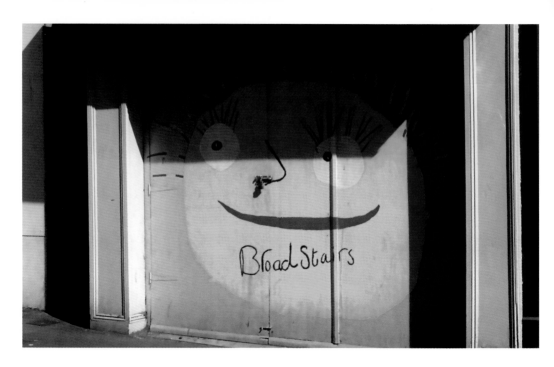

Broadstairs Shops II

Unlike many present provincial high streets, Broadstairs has a nostalgic vibrancy which has survived intact. To maintain this atmosphere the only two retail premises that are in disuse have been disguised by colourful murals, thus emphasising the care and cohesiveness expressed among the commercial community here.

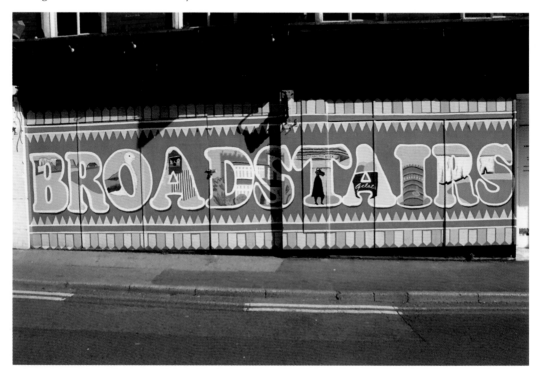

68

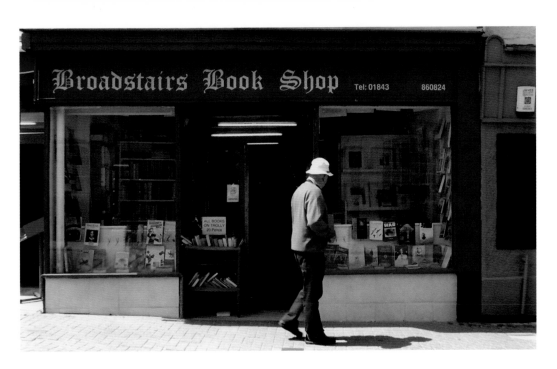

Broadstairs Shops III

Few towns of even medium size manage to support a book shop. The fact that Broadstairs has two says much for its residents and their traditional values. Behind the gothic facade of Broadstairs Book Shop customers are encouraged to browse for the perfect volume to read. At another book shop in a disused chapel, refreshments are also on offer while potential book lovers search the shelves.

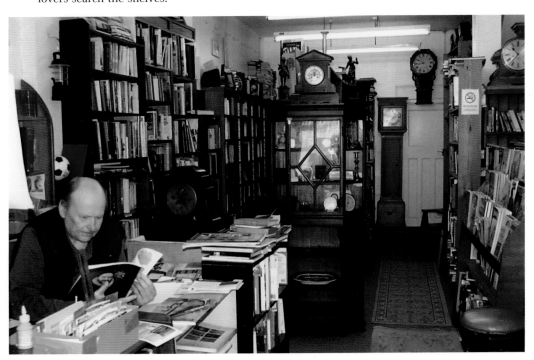

Broadstairs Shops IV

The emporium below is typical of those adjacent to bathing beaches throughout the United Kingdom. It sells those essential buckets and spades, cheeky postcards and balls for an idle kick-about. Above also is the ubiquitous amusement arcade without which one of the necessary flavours of the seaside resort would be incomplete.

Broadstairs Shops V
The smart boutique below is a powerful magnet for lady consumers. Its beautiful art-nouveax premises add to the buying experience with an unusual and attractive range of merchandise. Due to the old-fashioned, in every sense, nature of most shops selected and the poor quality of images found of before shots, no apologies are made for the contemporary nature of this section.

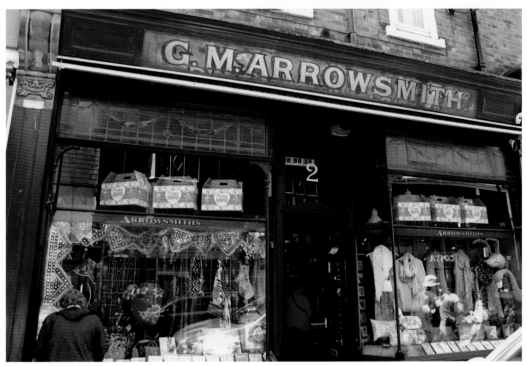

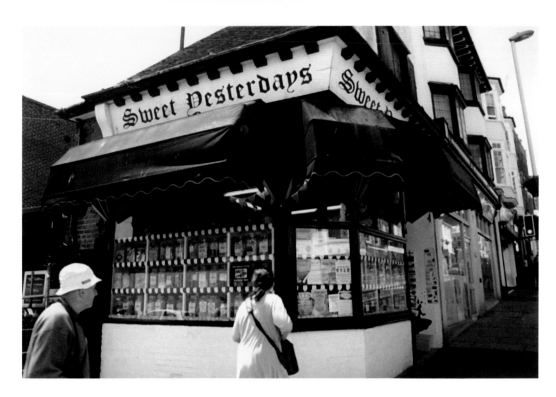

Broadstairs Shops VI

Sweet Yesterdays lives up to its name. On entering this shop one is excited to be confronted with shelves of colourful sweet jars containing such delights as chocolate brazil nuts and apple and rhubarb lozenges. In charge of this stock is the delightful Dona Loftus, whose wholesome smile is as genuine as her confectionary.

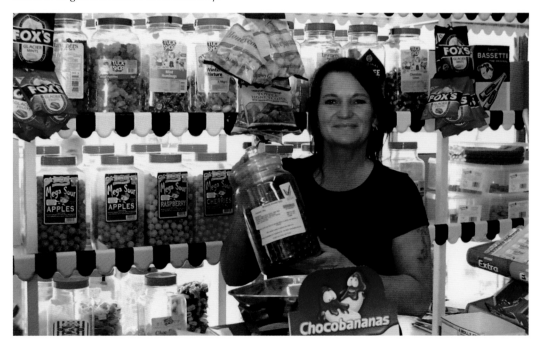

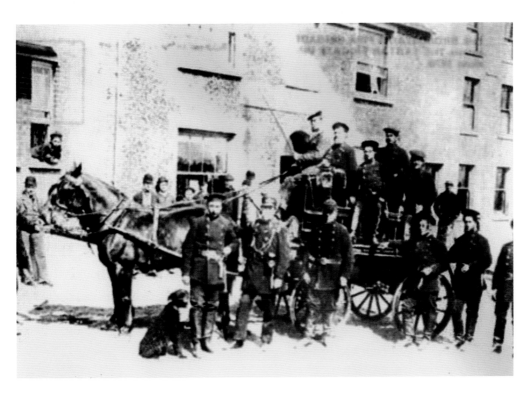

Victorian Firemen

The faded photograph above is of Broadstairs fire brigade in 1870. The print below, produced around this time also, from the *Illustrated London News*, shows them in action performing a demonstration at St Peter's. Responding to fire alerts then must have been a cumbersome, time-consuming business as it was first necessary to tack-up horses. Today, modern appliances are at the ready housed in Thanet Fire Station, Margate Road, Broadstairs.

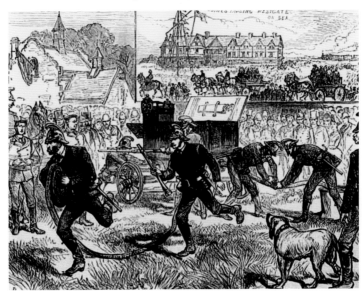

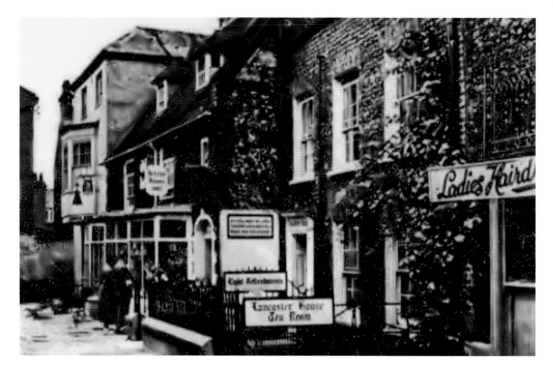

Serene Place
True to its name, this corner of Broadstairs is particularly peaceful and charming. Its terrace of flint-faced cottages has a quiet intimacy more generally found in the countryside. On the corner opposite is a greengrocer who relishes in building impressively colourful displays of his succulent produce.

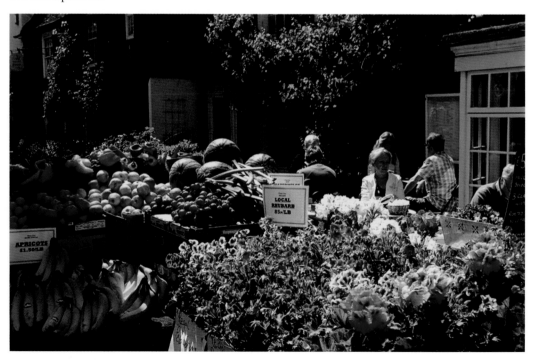

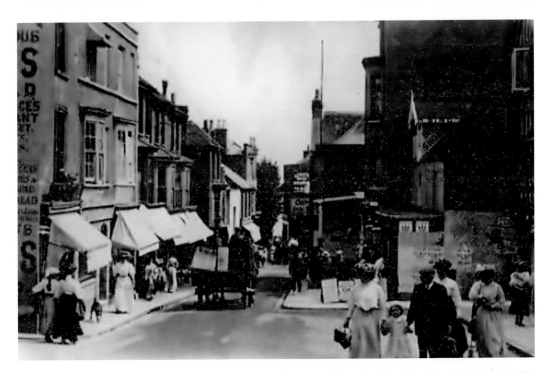

High Street

These images display the joyful descent down Broadstairs' High Street to the sea front. The period image above is peopled with ladies gracefully dressed in full-length skirts and everyone, without exception, is dressed formally in a hat. Sun awnings stretch out from shops over pavements. Today a bleaker outlook prevails as road traffic has dominated this scene.

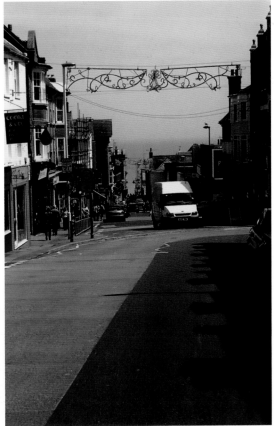

Pavilion and Garden on the Sands
The Pavilion Garden next to York Gate has direct access to the sands of Viking Bay. The property has a bar and function room and was sold at auction in March 2015 at a price far exceeding its estimated value.

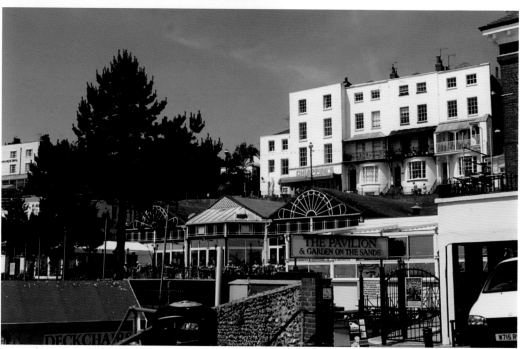

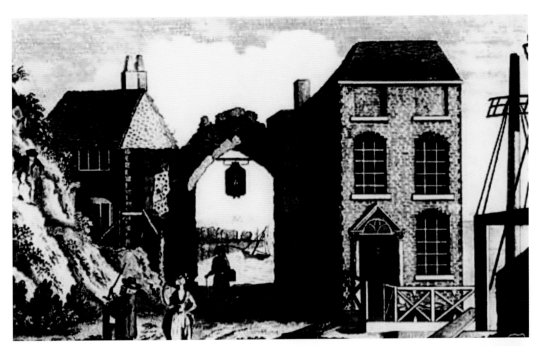

York Gate

Near the bottom of Harbour Street is York Gate, an old flint relic of the past. It was given to the town by the prominent Culmer family in the sixteenth century as a potential defence against invaders when its wooden doors or portcullis were closed. Its name is more recent and owes respect to an eighteenth-century Duke of York.

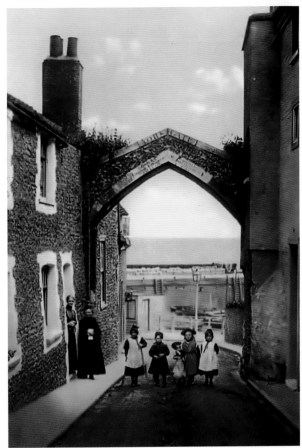

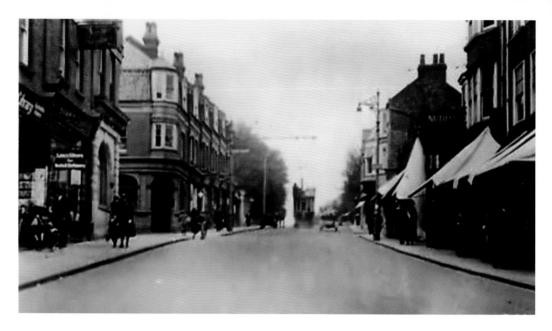

High Street looking Inland

Much of the solid-brick and stone development inland up the steeply rising High Street remain intact. A clutter of road signs has now been added together to create highway surface markings. The only vehicles captured on the horizon in the archive image illustrate a turning point in transport history, with a horse and cart on the left, a tram in the middle and an early 1920s car on the right.

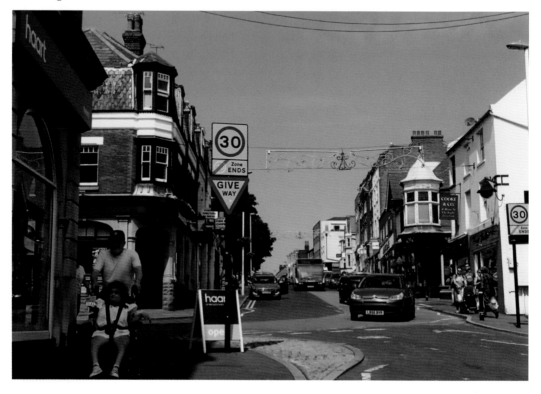

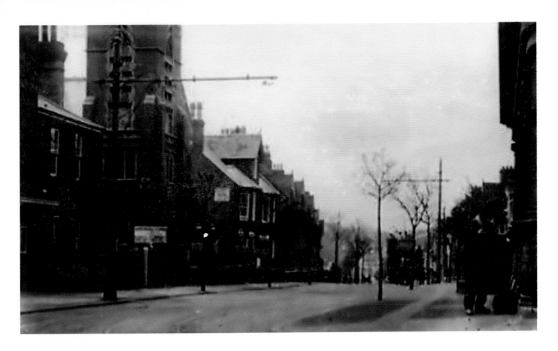

Queen's Street I

The main alteration in this section of Queen's Street has been the construction of new facilities for the Baptist church next to the older tower. Ideas for this project started in 2005, but it was only in June 2011 that it was completed and celebrated with an opening ceremony comprising over a 1,000 people. The church runs a café here open from 10.00 a.m. to 2.00 p.m. from Monday to Friday.

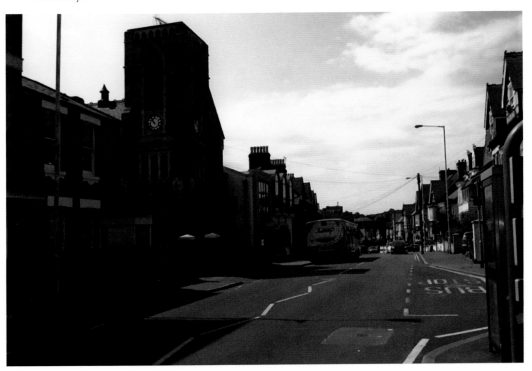

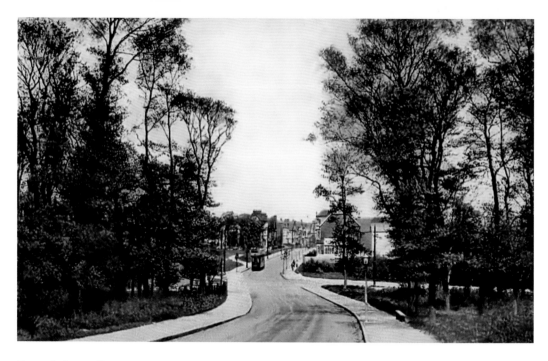

Queen's Street II

The distinctly rural scene above could be outer suburbia. It was, at the turn of the twentieth century, quite close to Broadstairs' teeming High Street. Fairly soon after this image was produced developers replaced the mature trees with proud Edwardian facades and jutting terracotta gables.

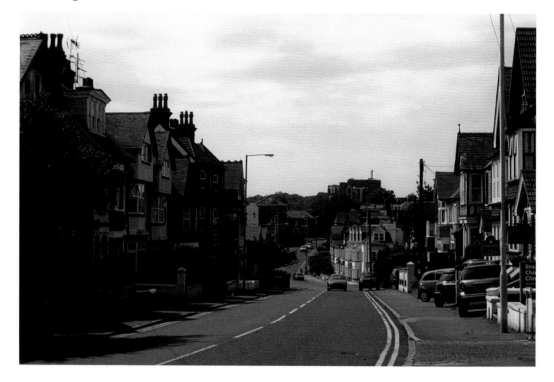

Ramsgate Road
Like Queen's Street, this main road out of Broadstairs is less leafy than it was years ago. Its turrets and bow windows however, are still smartly painted white.

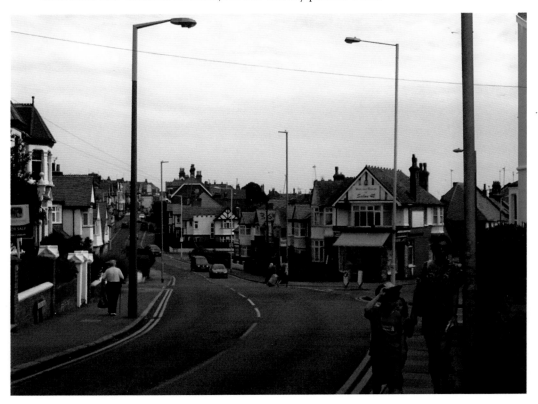

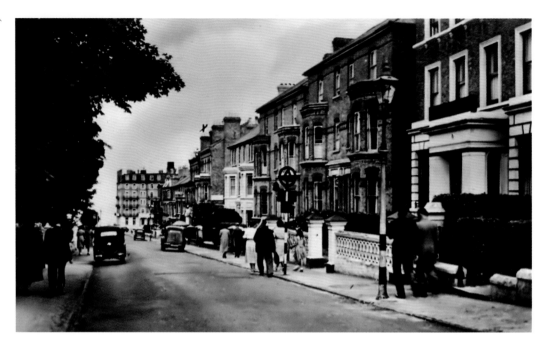

Granville Road

Granville Road has also seen some tree felling in the past judging from these before-and-after shots. Its grand multi-storey houses survive, albeit often now split into smaller flats. Some of these premises offered guest-house accommodation for holidaymakers in the summer.

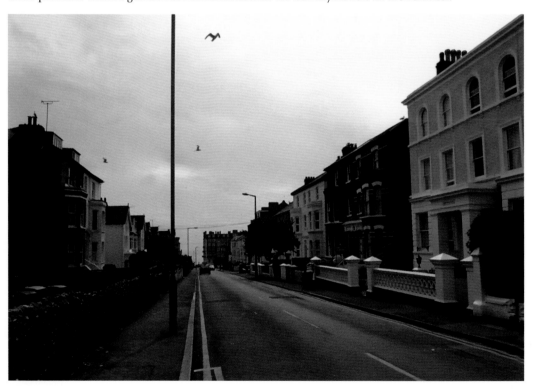

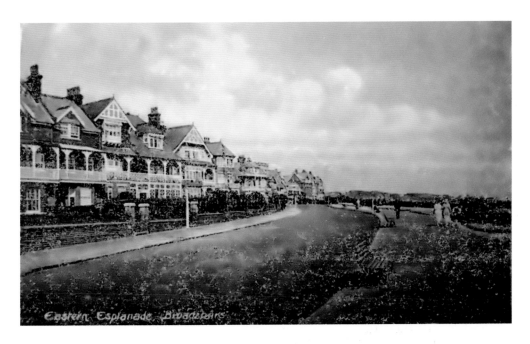

Eastern Esplanade

On the opposite hill to Dumpton Bay is Stone Bay. Its lofty position attracted house builders before town and country planning acts came into force. The results, nonetheless, were highly desirable as can be appreciated from these well-preserved homes at Eastern Esplanade. Their balconies afforded far-reaching views across the Channel

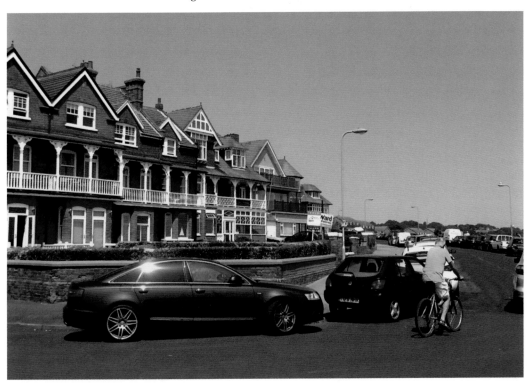

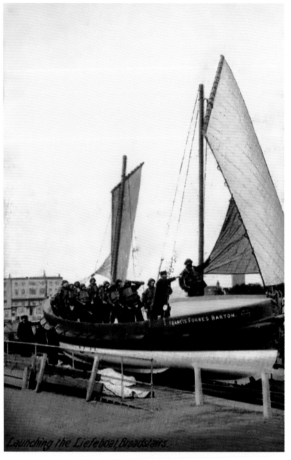

Launching the Lifeboat, Broadstairs.

Lifeboats

In 1850, Whites donated the first lifeboat to Broadstairs. It was sorely needed as there had been many sailors who had floundered on the nearby treacherous Goodwin Sands. Records of their successful rescues were posted on the harbour-building noticeboards. Perhaps the most famous and daring was the mission by the *Mary White* lifeboat men to assist crew of the wrecked *Northern Belle*. Currently, modern boats are on standby at Ramsgate and Margate only.

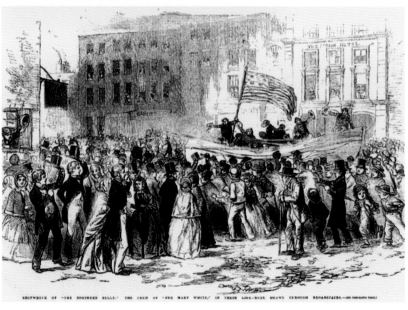

SHIPWRECK OF "THE NORTHERN BELLE." THE CREW OF "THE MARY WHITE," IN THEIR LIFE-BOAT, DRAWN THROUGH BROADSTAIRS.

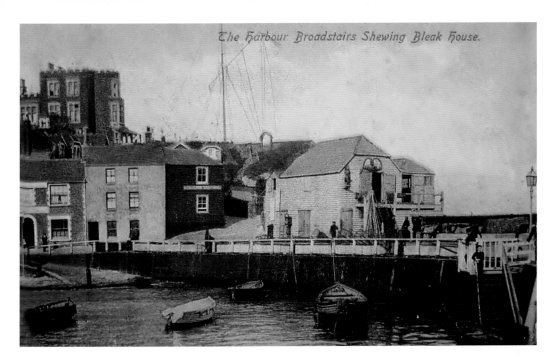

The Harbour Broadstairs Shewing Bleak House.

Harbour Building

Considerable change of use of the old wooded harbour building can be appreciated from these comparative pictures. The old postcard image is of a working building closely allied to marine life. Boat spars are stacked against its walls and its sail lofts are open for business. Meanwhile peak-capped men of the sea are dotted around following their trade. Below a variety of interesting artefacts decorate what is now a shop. The large round metal object is a sea-mine designed to magnetically attach itself to enemy vessels durnig the Second World War and destroy them with explosives. An iconic phone box designed by Gilbert Scott needs no explanation.

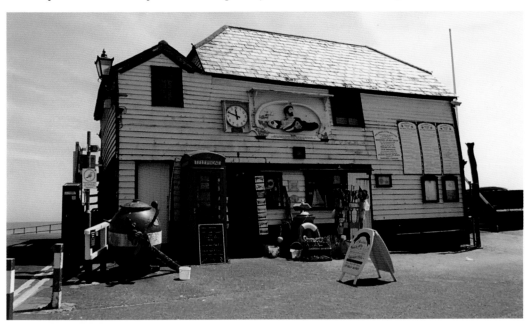

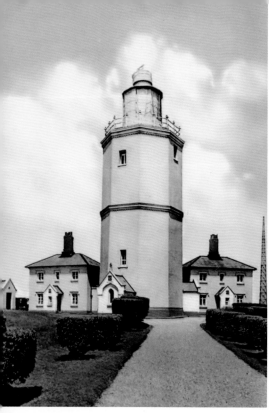

North Foreland Lighthouse

A lighthouse has stood on this site for at least 400 years. It was a vital navigational aid to mariners attempting to avoid the Goodwin Sands. Many improvements were made over the centuries as it evolved from merely a beacon to a modern fully-automated mechanism. In fact this was the last lighthouse in the United Kingdom to be manned; when the last keeper left in 1998 the Duke of Edinburgh made a visit.

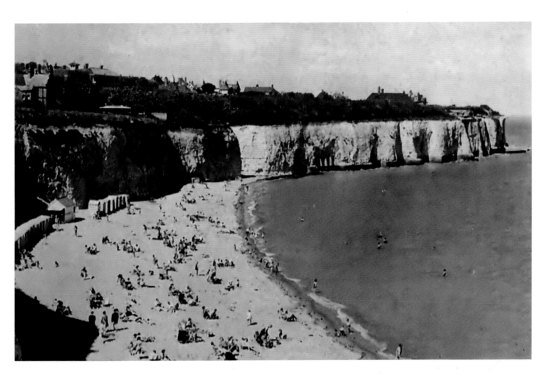

Stone Bay
Stone Bay, like Broadstair's other main bays, has benefitted from extensive coastal defence works. The concrete bulwark serves as a base for beach huts available to hire.

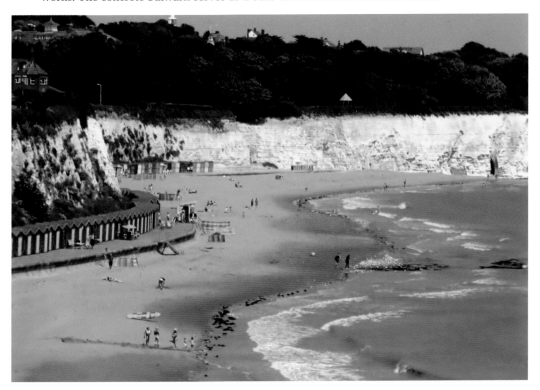

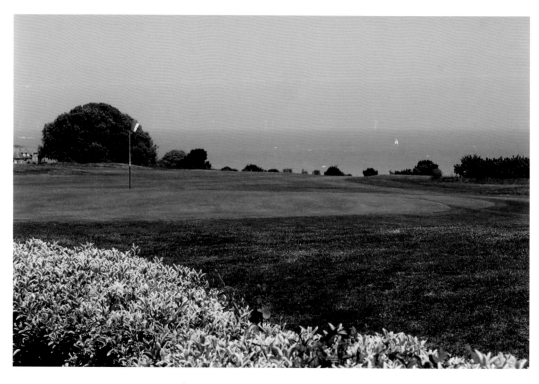

North Foreland Golf Course

Established over 100 years ago, North Foreland Golf Course is set on a stunning clifftop location. It is a 36-hole complex with an 18-hole par 71 course. The clubhouse, just off Convent Road, Kingsgate, provides modern well-appointed facilities.

Lord Northcliff's House

Lord Northcliff had a thatched house in the folds of North Foreland Golf Course. He was the proprietor of leading newspapers and a highly effective pro-war propagandist. To combat this, the German Navy shelled his residence in 1917 – they missed him, but killed his gardener's wife.

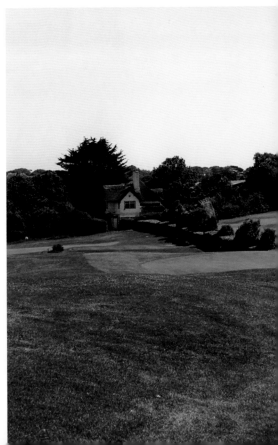

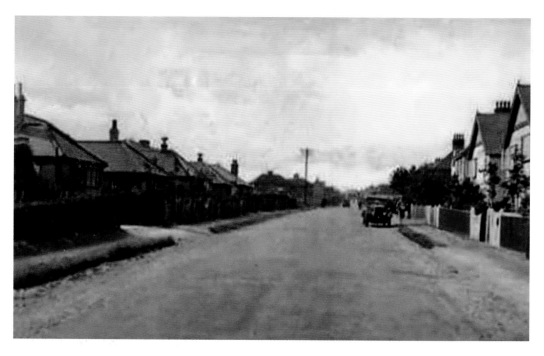

Percy Avenue, Kingsgate

Typical of the roads that form the hinterland community of Kingsgate is Percy Avenue. It is a mixture of bijoux bungalows and low-key houses. However, in 1913 the author D. H. Lawrence was to stay here in Rily House with Frieda Weekley, who was to become his wife.

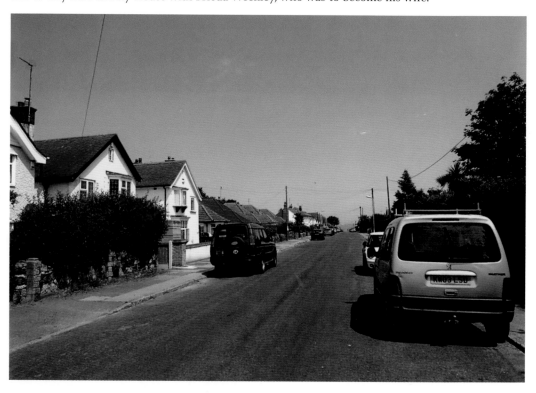

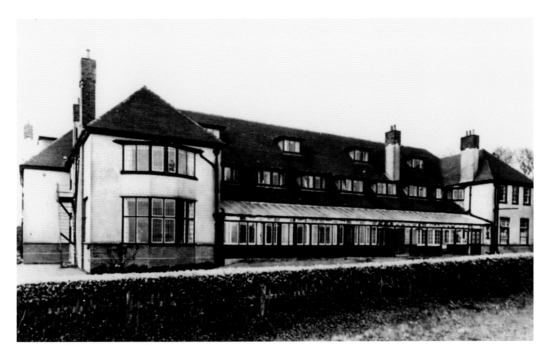

Kingsgate College

Formerly a residential college for short courses on industrial relations or economic discussion groups, this establishment is now run as a charitable organisation teaching Japanese students English language skills.

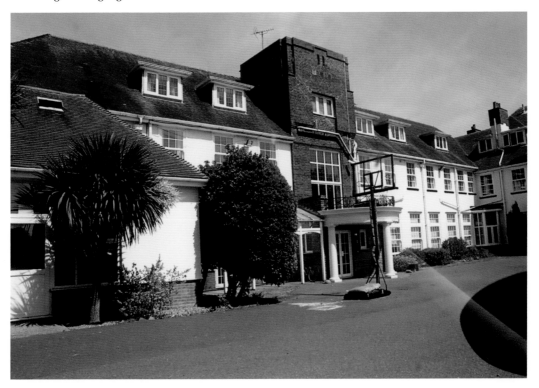

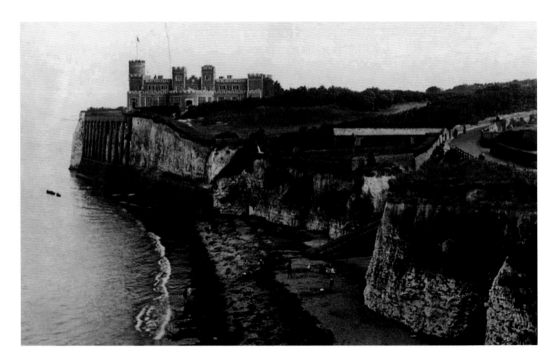

Kingsgate Castle

Kingsgate Castle has an unrivalled position atop chalk cliffs on Kent's most north-easterly headland. It was built for Lord Holland (Henry Fox 1st Baron Holland) in the 1760s. Later it was to become the home of John Lubbock, 1st Baron Avebury (of stone-ring fame). The name Kingsgate derives from a landing here in 1683 of Charles II. Currently thirty-one flats are contained within this striking structure.

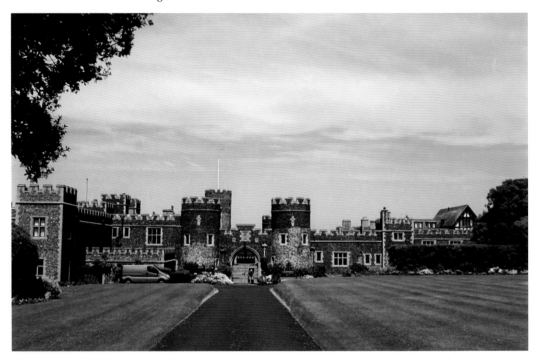

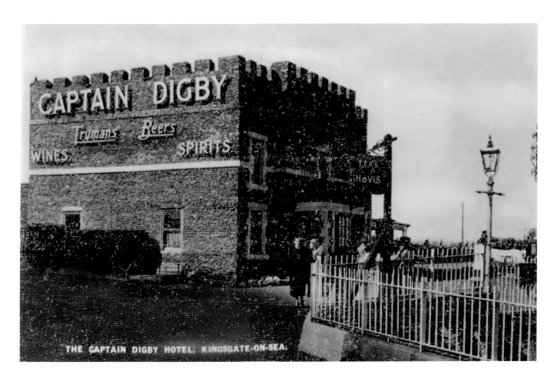

THE CAPTAIN DIGBY HOTEL, KINGSGATE-ON-SEA.

Captain Digby

Named after Lord Holland's nephew who commanded a ship in the English fleet in 1759, this pub and restaurant has been rebuilt and much altered. Originally it was known as Bede House and was provided for drinking and entertainment of the owners guests staying nearby in his magnificent flint castle. The present structure replicates its castellated walls. Below ground a large cavity is reputed to have been the hiding place for smuggler Joss Snelling and his notorious gang.

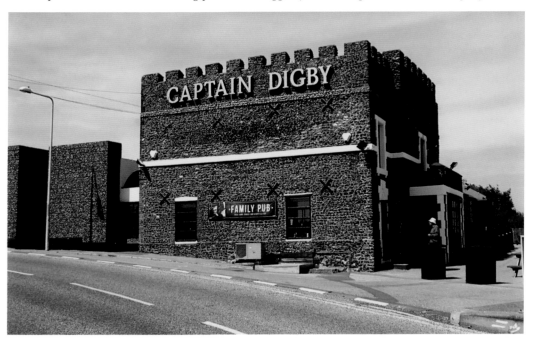

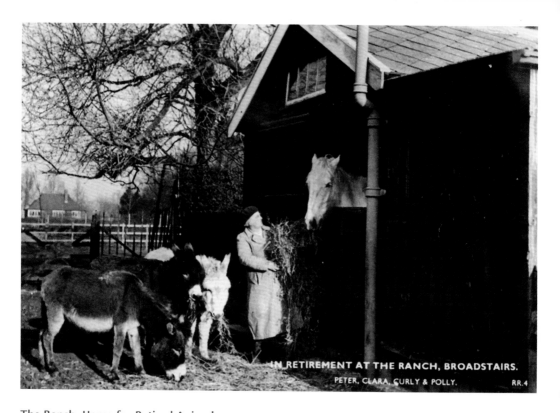

IN RETIREMENT AT THE RANCH, BROADSTAIRS.

PETER, CLARA, CURLY & POLLY. RR.4

The Ranch: Home for Retired Animals

In 1955 Enid S. Briggs wrote a book published by Raleigh Press describing the true story of how she founded The Ranch, a 5-acre estate for retired animals. The creatures, each personally named, seemed to have had an idyllic dotage judged from the photographs of them frolicking here.

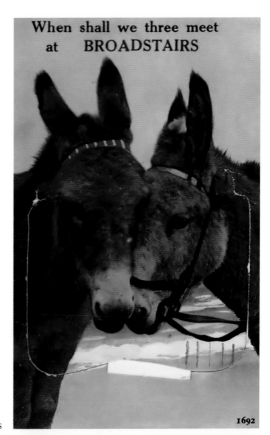

When shall we three meet
at BROADSTAIRS

1692

The Romance of the Seaside
Donkey rides still thrill young children on
Broadstairs sands, as they have done for
generations, and for the adults something in
the atmosphere continues to excite prospects
for romance. These vintage postcards
encapsulate wistful greetings sent from a
cherished and much-loved Kentish resort.

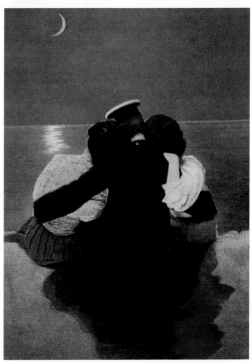

Acknowledgements

Thanks go to Trac Fordyce for her forbearance with computer snags and her cheerful unfailing help with transport. I am greatly indebted as always to my beloved partner Jocelyn Watson for her encouragement and unstinting support. I would also like to express my appreciation to Joanna Elvy for her photographic help. If I have failed to acknowledge other assistance I apologise and accept that any errors are mine alone. Last but by no means least, I would like to honour the editor of this book: Victoria Carruthers.

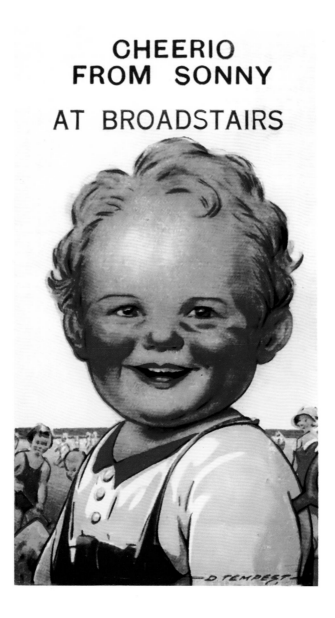